Images of Modern America

BRICKTOWN

Images of Modern America

BRICKTOWN

STEVE LACKMEYER
FOREWORD BY BRENT & BRETT BREWER

ARCADIA
PUBLISHING

Published by Arcadia Publishing
Charleston, South Carolina

Printed in the United States of America

Library of Congress Control Number: 2016938515

For all general information, please contact Arcadia Publishing:
Telephone 843-853-2070
Fax 843-853-0044
E-mail sales@arcadiapublishing.com
For customer service and orders:
Toll-Free 1-888-313-2665

Visit us on the Internet at www.arcadiapublishing.com

To Wendy, Kaden, and John, the marquee
names in the best story in my life

CONTENTS

FOREWORD

"Bricktown? Where is Bricktown?" That is the question our father, the late Jim Brewer, heard many times after he had purchased several brick buildings in the fledgling warehouse district in the late 1980s. Going through an oil bust and in the middle of a depressed economy, city leaders were saying that downtown was dead. One joking comment heard around town was that after 5:00 p.m., one could shoot a shotgun down the streets without hitting anybody.

Our father had recently sold his interest in an oil company and was approached about purchasing some foreclosed buildings in Bricktown from various banks. He and some potential investors went on a showing of the properties, and during the tour, one person in the group noticed that the building was filled with old antiques and cobwebs with no lighting. He said the property was creepy and that it would make a great haunted house. He then mentioned he knew a guy who ran a haunted house in Kansas City called The Edge of Hell. A trip to Kansas City was then organized, and by the end of that day, a deal was struck with the owner to fly to Oklahoma City and help design a haunted house. Our father then approached the bank about leasing the former Pittsburg Plate Glass Building—now named the Jim Brewer Building—for the project and to ultimately test the market to see if the general public would even consider coming to Bricktown.

Public perception of the area at the time was sketchy at best. The area had limited lighting and was littered with vagrants, prostitutes, and drug dealers. Before Interstate 235 was built, the downtown boundary to the east was considered the Santa Fe Railroad tracks, and Bricktown was essentially a no man's land.

The bank decided to lease the property for $1 for the event, and the Bricktown Haunted Warehouse became a reality. Bringing in temporary street lighting and advertising that the attraction was three blocks east of the Myriad, 18,000 people attended the inaugural event, and the Bricktown Entertainment District was officially on the map.

Steve Lackmeyer is a respected journalist and historian who has a special place in his heart for Oklahoma City. Lackmeyer has seen the "Oklahoma Standard" firsthand and how the people of Oklahoma City overcome adversity and strive to achieve greatness and follow their dreams. He challenges everyone involved in the stories he writes to make Oklahoma City a better place to live, work, and play. Steve always pushes people to their limits and stimulates conversations that ultimately lead to positive results. His passion reaches further than just journalism and history and can be seen in his relationships as a friend and a father.

This book is a must-read for anyone interested in the history and growth of downtown Oklahoma City. The Bricktown story is ultimately a story of how anything can be achieved through hard work, passion, and never giving up. It is a story that began with a small group of dreamers who turned an unlikely vision into a booming reality. This spirit is still evident today in the continuing renaissance of Oklahoma City and its inspiration in helping other historic neighborhoods and districts in Oklahoma City's urban core develop and reach its goals. Enjoy the journey.

—Brent and Brett Brewer

ACKNOWLEDGMENTS

In telling the story of Oklahoma City's history, an author must first visit the Oklahoma Historical Society. Archivist Rachel Mosmon is virtually a partner in these efforts, finding rare photographs and digging into the back stories. Kelly Fry and Linda Lynn, editor and news research editor, respectively, at the *Oklahoman*, generously shared the newspaper's archive photographs. Don Beck, an architect who worked with original Bricktown developer Neal Horton, discovered images packed in boxes for the past 30 years. Brent and Brett Brewer, whose father turned Bricktown into an entertainment district, shared their family's personal collection. Bill Peterson, Horton's partner, trusted me years ago with his photographs and promotional materials in telling the early story of Bricktown. Thanks again also to the City of Oklahoma City and the Greater Oklahoma City Chamber for their help over the years in providing images that help tell the story of how Bricktown emerged as a regional urban entertainment destination. Some great images also were provided by photographer Michael Downs.

Without the support and patience of my family, authoring books about city history would not be possible. They nudge me to work and get work done as needed, and they remind me when a break is needed. Chad Huntington, operator of the Bricktown Water Taxis, is faithful in providing feedback and not shying away from telling me when my recollection of events is lacking. Final thanks go to my readers, who have encouraged me throughout the years and always remind me that these stories are worth keeping alive.

INTRODUCTION

It started with a gunshot. Legally, there were no residents at all in Oklahoma City when gunshots rang out on April 22, 1889. The shots heralded what may be one of the most sudden births of a city in the history of mankind. The Oklahoma Land Run of 1889 offered hope and opportunity for anyone brave enough to stake their lots and gamble their fortunes that a great city would rise at Oklahoma Station. With a river flowing through it and ample rail access, this new city's population quickly swelled to 10,000.

One area of this new city, however, was initially off limits. Troops from Fort Reno established an outpost east of the Santa Fe Railroad tracks. Once convinced that law and order had been established, the troops withdrew, making the area ripe for development. A decade after the land run, Congress instructed the city to plat the area and sell the properties with proceeds benefiting public schools. The deal also called for construction of a school and creation of a park along the North Canadian River.

The former outpost was fertile ground for industrial development. Wholesalers and distributors, many from Chicago, set up shop along the Santa Fe tracks early on. Rock Island tracks and Katy tracks formed the south and north borders to the city's new wholesale district. Some industries flourished. Wholesale grocers like Williamson-Halsell-Fraser and Carroll, Brough & Robinson became major regional distributors. Oklahoma Sash & Door and the Federal Steam Company helped build the new city. The First State Ice Company kept the new city cool and also provided the critical element to ensuring wholesalers' success. Households were furnished and maintained with goods from the Miller-Jackson Company and Oklahoma City Hardware. The Iten Biscuit Company put bread on families' tables, while the Steffen's dairy provided them with milk.

The wholesale district also became an important regional hub for agriculture and cotton production. Implements dealers with names of Kingman, Rock Island Plow, and International Harvester set up shop to provide everything a farmer might need while taking care of the business in the big city.

As Oklahoma was set to be granted statehood in 1907, the district moved more than $28 million worth of merchandise, ranging from fresh produce to farm equipment and furniture.

The wholesale district persevered and continued to grow through World War I and beyond. Grand new passenger depots were built by the Santa Fe and Katy Railroads. Even in the midst of the Great Depression, the city and the Santa Fe Railroad joined together to build a raised viaduct that would allow for the safe passage of cars and pedestrians under the busy tracks.

The area thrived for a half century, but the 1960s marked the start of a long decline, not just for the warehouse district, but for all of downtown as the city sprawled out over 622 square miles. Industries relocated to new rail corridors along NE 36 and Santa Fe Avenue and, later, along Santa Fe Avenue between Hefner Road and Memorial Road.

Buildings were abandoned. A few businesses, notably Bunte Candy, Federal Supply, and Stewart Metal Fabricators, remained in operation. Liberty Bank briefly toyed with an idea to clear the block at Oklahoma and California Avenues to build a 30-lane drive-through.

The area dismissed as obsolete and destined to be destroyed was set for a comeback. Two men, Neal Horton and Jim Brewer, kicked off a revival that, over three decades, resulted in the state's premier urban entertainment district. The pair could not have been any different.

It is difficult to imagine two people with less in common than Neal Horton and Jim Brewer. The two late Bricktown developers were Oklahoma City's Felix and Oscar—and it is difficult to imagine the district being what it is today without them.

Horton, the son of banker Myron Horton, grew up in an upper-middle class family with all of the advantages that came with such status. His first real estate ventures involved about 500 apartments and 100 condominiums. The recession hit him hard in the mid-1970s, with the commercial real estate sector in Oklahoma seriously overbuilt.

Horton liquidated and started over. He sought out investors from a diversity of backgrounds to guard against becoming too vulnerable to the shifting fortunes of the energy industry. He also dedicated himself to pursuing quality over quantity in his projects.

Horton caught the preservation bug while visiting Breckenridge, Colorado. He returned and first cut his teeth with a less-than-inspiring renovation of the Oil and Gas Building at Robinson Avenue and Main Street. He then embarked on a far more ambitious and lauded effort restoring the Colcord Building.

He found original blueprints in a closet that probably had not been opened for 20 years. The restoration saved the Colcord from the Urban Renewal wrecking ball. Carpeting and tiling were removed to expose marble floors, old fixtures were restored, and exterior blocks were recast.

His next project started with a glance from his office window on the Colcord's 11th floor—the old warehouse district he would rename Bricktown.

"A city's history is in its buildings," he recalled in a 1982 interview. "My father, Myron Horton, had his office in the building across the street, next to where the Oklahoma Club was (now the Myriad Gardens). My father and mother used to go to dinner in the Savoy Restaurant in the basement of this building for 85 cents on Sunday."

Horton teamed up with Bill Peterson and John Michael Williams and started buying and securing control of properties centered along Sheridan Avenue. His ideas for restoring warehouses and turning them into offices with a small mix of restaurants and shops were visionary for Oklahoma City. His assumptions, however, required a thriving downtown office market and rents that would support high construction loan interest rates. Horton traveled across the country and through Europe buying furniture and fixtures for buildings he was starting to renovate.

Horton and Peterson restored the Glass Company Building (116 East Sheridan Avenue) and the Confectionary Building (120 East Sheridan Avenue), constructed a parking lot, and put in the antique-looking street lights and signs before the oil boom collapsed in 1983. In just two years the office vacancy rate jumped from no available space downtown to 36 percent. Horton shifted his emphasis from offices to a mix of hotels, shops, and restaurants.

"Maintaining the plans for Bricktown is a significant battle in the war to bring back downtown and create a lively downtown," he explained. "There are 486,000 conventioneers in downtown Oklahoma City each year and there's nowhere for them to go but downtown bars. A nice restaurant and shopping area would be beneficial to people living in the central core area. The only limit to this project is the creativity of those who lease it."

The real estate market was crashing. With no uptick in leasing, Horton was hit with loan foreclosures. Horton's Warehouse Development Company filed for bankruptcy in September 1984, listing liabilities totaling $1,216,402 and assets totaling $645,358.

And that is where Brewer entered the picture. Horton was a fine dresser and sophisticated, someone who reminded people of Robert Young from *Father Knows Best*. Brewer was not any of the above. He was a rough and tumble "Southsider" who scraped his way into a small fortune in the oil patch. If Horton was the visionary, Brewer was the guy who could pare that dream down to size and make it doable. He was a natural promoter.

Brewer's life was a classic rags-to-riches story—a boy born in poverty who never knew his father and as a child once had to live in a chicken coop. At his death in 2008, Brewer was one of the

largest landowners in Bricktown with an empire worth millions. Brewer's climb out of poverty began with work at his uncle's salvage yard, where he tinkered with car transmissions. That then led to Brewer opening his own transmission shop.

An acquaintance introduced him to the nightclub business, which then allowed him to invest in oil. He took in $600,000 from the Tom Cat well in western Oklahoma in just one day. Calls came in from across the country from investors looking to buy any parcels near Brewer's big discovery. His next deal was the clincher that would finance his next phase in life: a contract with Oklahoma City to drill on leases at Will Rogers World Airport. Brewer could have kept on going, but he sold his interests just before the oil crash.

Brewer had money to invest, and Horton's partner, John Michael Williams, was a fellow Southside acquaintance. Brewer bought some of the bankrupt Warehouse Development Company properties. Brewer shared Horton's vision, but Brewer knew the restaurants and shops would only follow existing foot traffic. Brewer started a yearly "haunted warehouse" and launched festivals to bring people into Bricktown. The opening of Spaghetti Warehouse in 1989 proved Brewer right—and ultimately made Horton's dream a reality.

Over the next quarter century, Bricktown went through one wave of reinvention after another. A recreational canal with popular excursion boats and a vintage-style baseball stadium provided the next big boost, followed by a wave of new restaurants, shops, clubs, and entertainment venues. Housing followed along with a handful of corporate headquarters. The West End in Dallas died in the late 1990s after being proclaimed the model for old-town districts after the opening of a Planet Hollywood. But Bricktown stayed true to its local roots, even as it grew into the state's most popular tourist destination.

One

BRICK TOWN USA

Neal Horton's interest in development began while he was a banker, and during trips to Colorado in the late 1970s, Horton saw the success of historic preservation in Denver's Larimer Square.

He concluded a similar opportunity existed in a fading warehouse district east of downtown. Where others saw the brick warehouses as an eyesore, Horton saw a historic district that would draw people yearning to experience the city's past. Attorney Bill Peterson, meanwhile, saw a similar opportunity with the former Iten Biscuit plant and commissioned an architect to draw up plans to convert the warehouse into a retail mall. Peterson lost the deal to U-Haul. Peterson's effort, however, caught the attention of Horton, and they teamed with former city land attorney John Michael Williams to form the Warehouse Development Company. They then began doing deals with wholesale district property owners, many of whom were living out of state.

The plan for Bricktown (initially marketed as "Brick Town USA") assumed the oil boom of the early 1980s would continue and downtown office space would remain at full occupancy. The partners agreed to double-digit interest rates on construction loans, fully anticipating they could capture a lease rate of $15 a square foot or better. They dreamed up lists of potential tenants—shops selling candies, antiques, clothing, music, and art, along with restaurants, bars, delis, and a radio station.

Renovations started in 1982, just as the boom turned to bust; energy prices dropped, and energy loans took down dozens of banks. Downtown occupancy rates plummeted. Horton, Peterson, and Williams continued on, hoping the downturn would be short-lived. They continued to promote Bricktown as the state's first urban entertainment district and tried to negotiate deals for offices and restaurants.

Horton was mocked behind his back. City planners suggested he might have fared better by razing all the warehouses and starting from scratch with a new office park. Warehouse Development Company was going broke, and Horton's car was reposed as he was negotiating a grant with the Department of Housing and Urban Development to build a parking garage. The partnership declared bankruptcy on September 18, 1984.

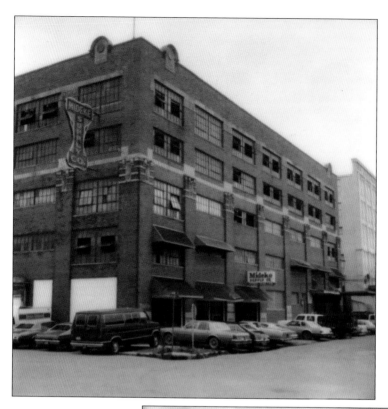

The Mideke Building at 100 East Main Street was constructed in 1919 and was home to the Mideke Supply Co. for 87 years. The company operated as a supply house for grain elevators, cotton mills, power plants, oil fields, plumbers, and bridge and road builders, and later, for refrigerators and air-conditioning. The operation closed during the 1980s oil bust. (Courtesy of Beck Design.)

Decades-old warehouses at 1 and 27 East Sheridan and 1 North Oklahoma Avenues were acquired by R.T. McLain for his Bunte Candy Company, which dated back to a non-chocolate confection company founded by two German brothers in 1876 in Chicago. The operation continued through the 1980s before moving to a new plant in north Oklahoma City. (Courtesy of Beck Design.)

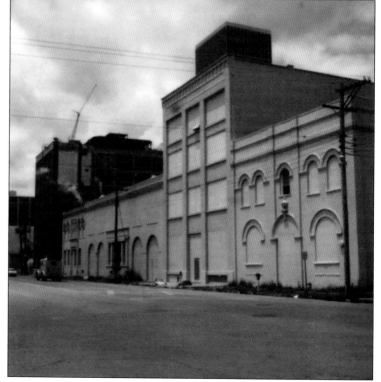

The Rock Island Plow Building, 29 East Reno Avenue, was already empty when Neal Horton started developing Bricktown in 1979. The building was constructed in 1909 by the Rock Island Railroad Corporation of Chicago. The company, which specialized in farm implements, collapsed in 1932 during the Great Depression. (Courtesy of Beck Design.)

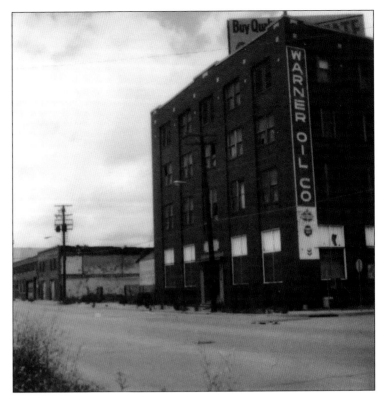

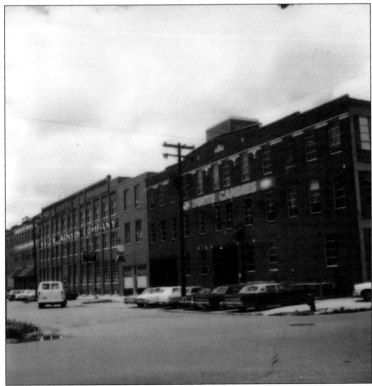

The three-story building at 129 East California Avenue was built in 1928 and home to several tenants, including Bunte Candy Company. The building was eyed for acquisition by Neal Horton and his partners but was never a part of his Warehouse Development Company. In later years, the facade was stripped off, a new floor was added, and the property was renamed the JDM Building. (Courtesy of Beck Design.)

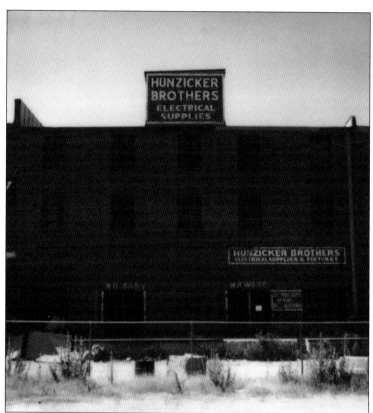

One of the largest buildings acquired by Neal Horton's Warehouse Development Company was the former home of Hunzicker Brothers, a firm established in 1920 with a train carload of light bulbs. The sales operation expanded to automotive accessories, wiring supplies, light fixtures, and appliances. The company moved from its home at 101 East California Avenue in 1960 to a new home at 501 North Virginia Avenue. (Courtesy of Beck Design.)

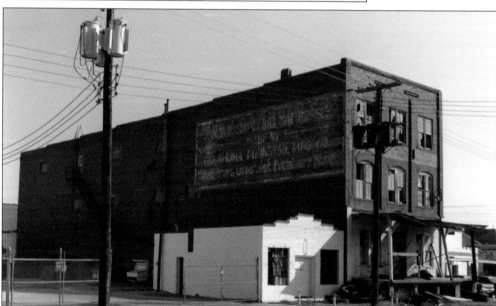

The three-story building at 121 East Sheridan Avenue dates back to at least 1904, when it was used for mattress assembly and sales by the Oklahoma Furniture Manufacturing Company. The building was one of several for which Neal Horton secured an option to buy the property but lost the deal when his company later went bankrupt. (Courtesy of Beck Design.)

Neal Horton started as a banker but fell in love with developing historic buildings. He sought to create a master plan for redeveloping Bricktown after spotting the brick warehouses from his office window at the Colcord Building. (Courtesy of the Oklahoma Historical Society.)

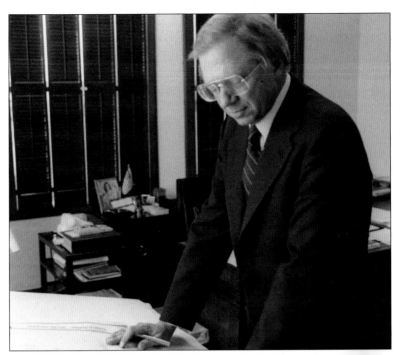

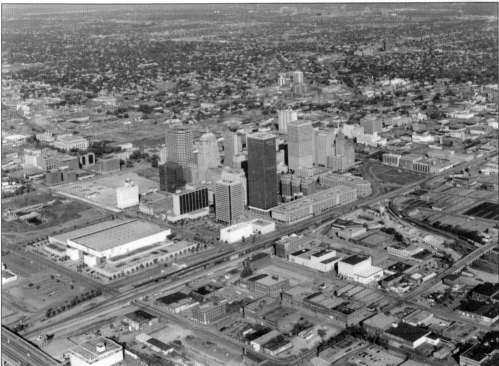

The warehouse district east of the Central Business District still had a few viable industrial operations left when Neal Horton started acquiring properties in the early 1980s. Several buildings were vacant, some for years, and the district started to decline in the 1960s. (Courtesy of the Greater Oklahoma City Chamber.)

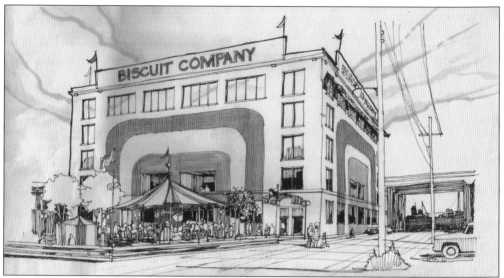

Bill Peterson sought to acquire the former Iten Biscuit factory for redevelopment as a mall. U-Haul bought the property, and Peterson partnered with Neal Horton in acquiring and redeveloping other properties in Bricktown. (Courtesy of Bill Peterson.)

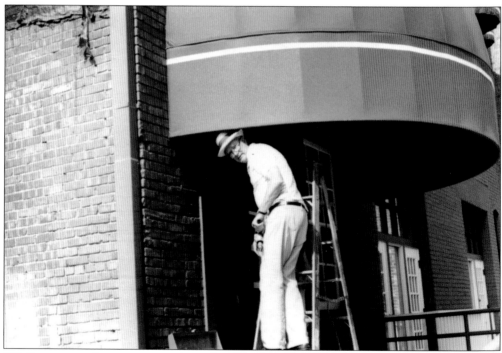

Bill Peterson works on awnings along the alley side of the Glass Company Building and the Confectionary Building. The properties were the only development close to completion when the Warehouse Development Company declared bankruptcy. (Courtesy of Bill Peterson.)

A master plan created by Howard & Porch for Neal Horton's Warehouse Development Company suggested creation of a parking garage and a pedestrian plaza in the heart of the development. (Courtesy of Beck Design.)

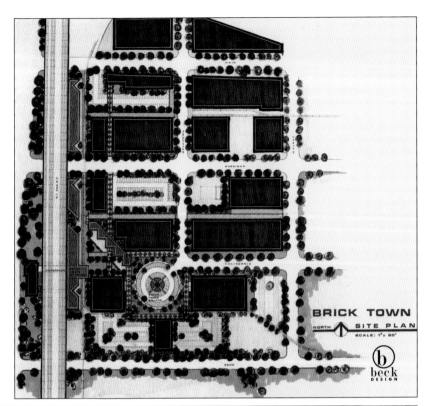

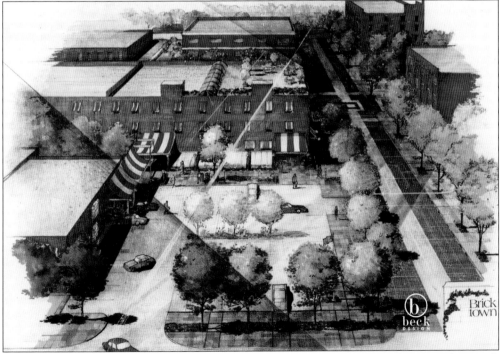

The Hunzicker building, envisioned as a key gateway property, was drawn up by Howard & Porch for Neal Horton's Warehouse Development Company. (Courtesy of Beck Design.)

Marketing materials sought to attract office tenants, restaurants, and retailers to Bricktown as Neal Horton drew up lists of potential occupants for the renovated buildings. (Courtesy of Bill Peterson.)

The Glass Company Building and the Confectionary Building posed a challenge to the Warehouse Development Company. How could the buildings' best features be preserved while adding elevators and bringing in more sunlight without cutting available space in half? The answer by Howard & Porch was to tear out the walls between the two buildings and add an atrium and a shared set of elevators. The confectionary was originally home to the Henry Brown Confectionary Shop. (Both, courtesy of Beck Design.)

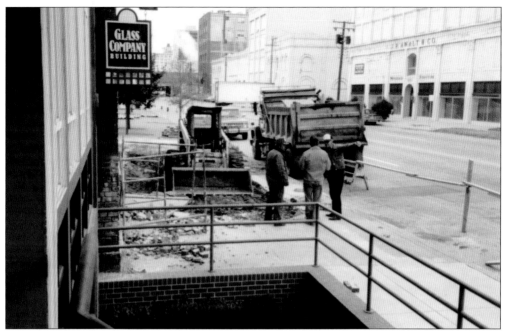

A touch of the New York streetscape was bought to Sheridan Avenue when the Warehouse Development Company decided to add sidewalk wells to the basements of the Glass and Confectionary Buildings. The intent of the design was to add sunlight and patios to the basement levels. (Courtesy of Beck Design.)

Neal Horton spared no expense in the design and construction of the Glass and Confectionary Buildings; however, leasing was slow as downtown office occupancies plunged with a severe downturn in the energy industry. (Courtesy of Beck Design.)

Neal Horton inked a deal with the Central Oklahoma Transportation and Parking Authority to lease vintage-style trolley busses and run them between Bricktown, Automobile Alley, and the Central Business District as a means of generating traffic into Bricktown. (Courtesy of the Oklahoma Historical Society.)

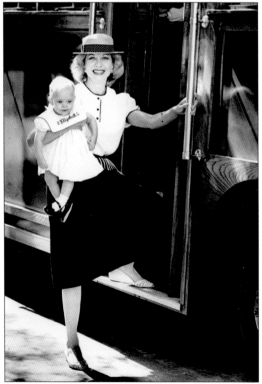

Susan Crain and her daughter Elizabeth board the Elizabeth Crain Bricktown Trolley, which was dedicated to Elizabeth. The trolleys were often used for local charity events when not running visitors to and from Bricktown. (Courtesy of the Oklahoma Publishing Company.)

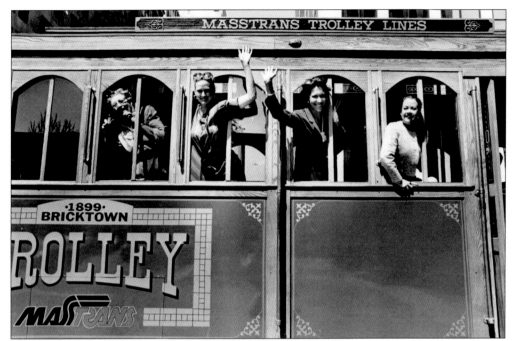

Oklahoma City Museum of Art volunteers, from left to right, Aileen Frank, Cheryl Browne, Leslie Wileman, and Toni Wizenberg take a trip on the Bricktown trolley north from downtown during a special excursion. (Courtesy of the Oklahoma Publishing Company.)

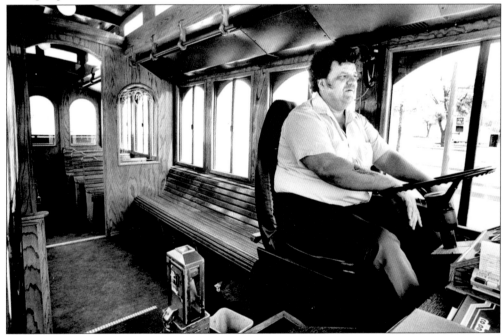

Ridership on the Bricktown trolleys was erratic following the downturn in the economy and the fate of Bricktown uncertain following the bank takeovers of Warehouse Development Company properties. In a 1985 interview, driver Duane Thomas said business on his trolley varied with the time of day and day of the week. (Courtesy of the Oklahoma Publishing Company.)

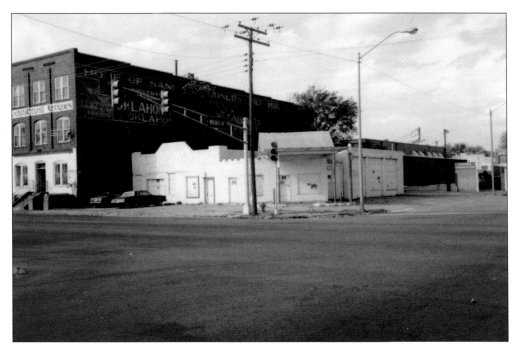

A vintage gas station immediately west of the Walnut Avenue bridge was one of several structures torn down by the early 1990s to make way for parking. (Courtesy of the Oklahoma Publishing Company.)

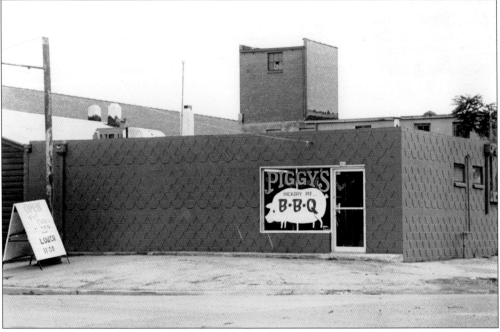

Piggy's Barbeque was the one restaurant opened during the early 1980s that survived the bust of the Warehouse Development Company's plans to make Bricktown an old-town destination. The restaurant operated in a small former taxi stand. Though the location was obscure at the time, annual sales hit $375,000. (Courtesy of the Oklahoma Historical Society.)

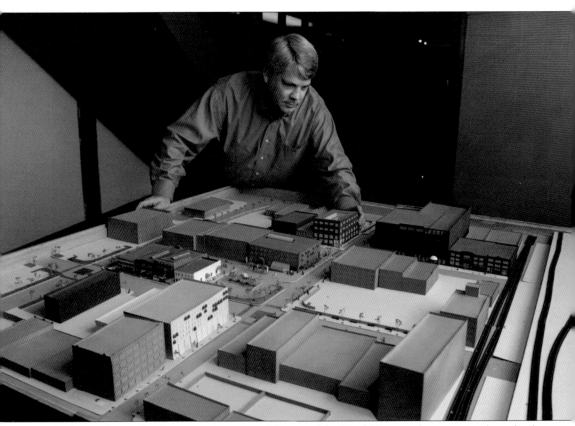

Architect Bruce Faudree examines a model created by Neal Horton that remained on display through the late 1990s in the basement of the Glass and Confectionary Buildings. The model was later vandalized and discarded. (Courtesy of the Oklahoma Publishing Company.)

Two

JIM BREWER

The Bricktown vision did not end with the bankruptcy of the Warehouse Development Company. Jim Tolbert and Don Karchmer were turnaround experts who bought the Glass and Confectionary Buildings that were closest to completion when Horton's venture ended. They completed the job and moved in and thus maintained a stable presence in an area still avoided by the public. Oilman Jim Brewer toured available properties with Craig Brown, who previously had been involved in development of Crossroads Mall. Brewer and Brown together realized the old Hunzicker building, filled with Horton's antiques, reminded them of a haunted warehouse. After touring a similar operation in Kansas City, they did a deal in 1985 with bankers to lease the Bricktown warehouse. The Bricktown Haunted Warehouse was a huge success, and Brewer instantly became the P.T. Barnum of Bricktown.

Brewer had succeeded where Horton had failed—he had found a way to draw crowds to Bricktown. He launched music festivals and holiday celebrations to generate interest in his properties. Slowly, the district's fortunes began to turn around with a few offices leased by Tolbert and Karchmer and clubs lured in by Brewer. Rick Garrett, another partner with Brewer, opened a gas station and convenient store. Architectural Antiques opened in a building originally targeted by Horton as a potential deli. The final spark to set Bricktown in motion, however, would be the opening of Spaghetti Warehouse in 1989. Founder Robert Hawk followed a blueprint for choosing where to expand. Only an old building in a run-down urban setting would work, and the community had to have a population of at least 100,000. Bricktown fit the bill perfectly, and lines formed outside the restaurant nightly when it opened in the old Oklahoma Furniture Manufacturing factory.

Having once operated nightclubs as a younger man, Brewer went back into the business with O'Brien's, an Irish bar with dueling piano players and karaoke. Bricktown was a hit and was featured on a June 1991 episode of *The Today Show* as legendary weatherman Willard Scott promoted an upcoming Fourth of July celebration and tribute to Desert Storm veterans.

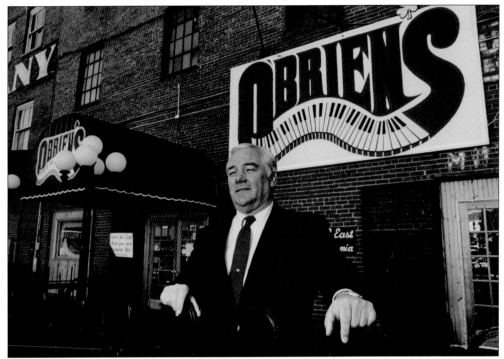

Jim Brewer did not acquire all the properties once controlled by Neal Horton and was very different in his approach to development. Brewer did better than his predecessor in promoting the district and creating the illusion of a destination with a wide array of entertainment. (Courtesy of the Oklahoma Publishing Company.)

Jim Brewer used antique furnishings left by Neal Horton in the Hunzicker building to create a Bricktown Haunted Warehouse at 101 East California Avenue. The haunted warehouse was an instant hit and is still going 30 years later. (Courtesy of the Oklahoma Publishing Company.)

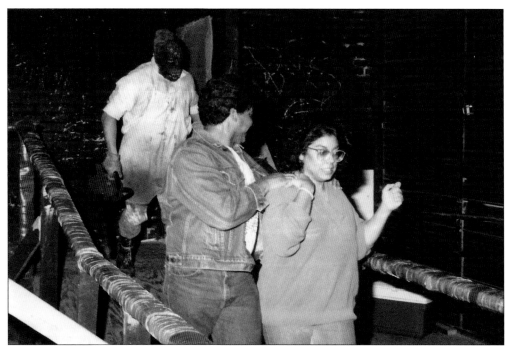

Jim Brewer told visitors they could get a good scare by traveling east of the Myriad Convention Center into a spooky old warehouse district populated by vampires, chainsaw killers, zombies, and homicidal doctors. Brewer employed a cast of young actors to ensure his guests all left with a good scare at the annual Halloween haunted house. The Bricktown Haunted Warehouse successfully taught a generation of Oklahoma City residents how to get to Bricktown and gave them a glimpse of its future potential. (Both, courtesy of Brewer Entertainment.)

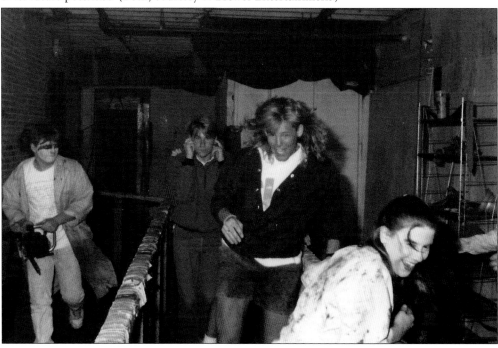

Jim Brewer frequently treated his Bricktown Haunted Warehouse cast to a pizza dinner after a long shift of scaring thousands of young visitors. The dinners were a part of the haunted warehouse tradition for years. Some cast members returned for repeat performances year after year. (Both, courtesy of Brewer Entertainment.)

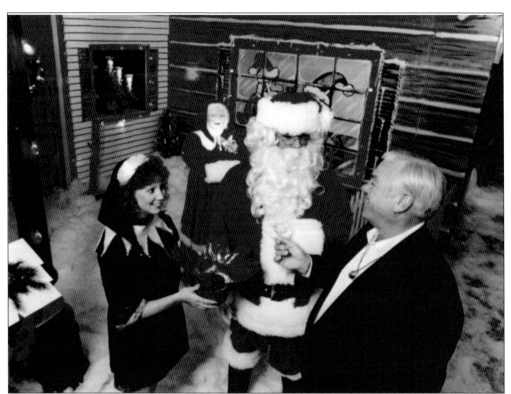

Brewer briefly sought to expand seasonal activities in Bricktown with the addition of a Christmas village, Santa Land, following the ending of the annual Bricktown Haunted Warehouse. The event was short-lived, though the idea of making Bricktown an annual Christmas holiday destination would be successfully revived in later years. (Courtesy of the Oklahoma Publishing Company.)

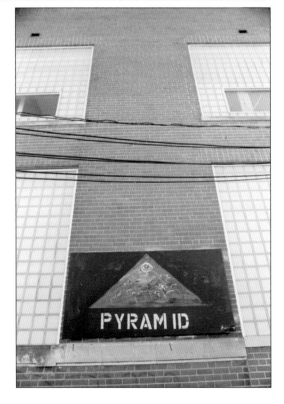

The Pyramid Club was one of several alternative venues that operated along California Avenue in the late 1980s and early 1990s, when the street was relatively desolate compared to Sheridan Avenue. Graffiti from the nightclub was still visible when the Kingman building was later renovated into retail, offices, and upstairs lofts. (Courtesy of the Oklahoma Historical Society.)

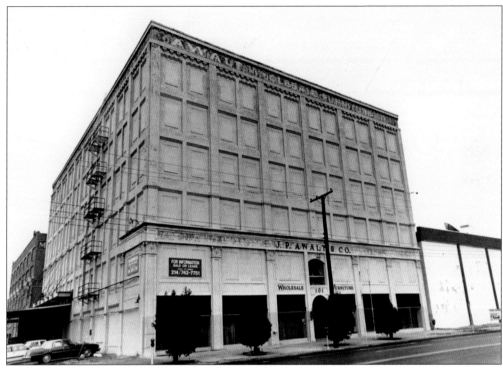

The former home of Oklahoma Furniture Manufacturing, later Awalt Furniture, was painted in white before the building was restored by Bob Hawk, owner of Spaghetti Warehouse. The redevelopment restored the exterior but left windows of the floors above the second story filled in with brick. The upper floors remained empty through the restaurant's closing in 2016. (Both, courtesy of the Oklahoma Historical Society.)

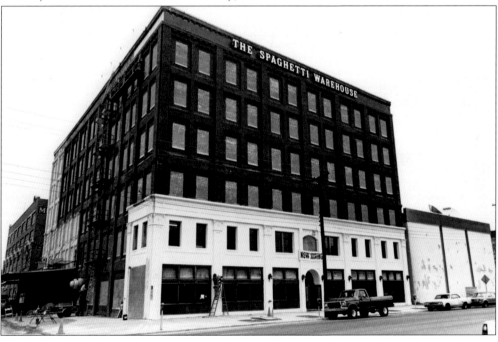

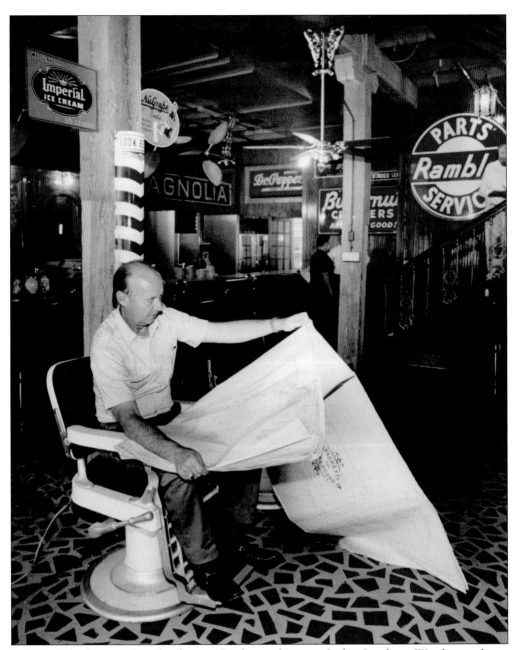

Bob Hawk looks over plans for the new Bricktown location for his Spaghetti Warehouse chain, which got its start in Dallas's West End district. Hawk predicted the 1989 opening for the Bricktown restaurant would spark a transformation similar to one that had transpired in West End, also an old brick warehouse area, which then boasted 27 restaurants, 15 night clubs, at least 55 shops, and several travel agencies. (Courtesy of the Oklahoma Publishing Company.)

The Spaghetti Warehouse opened to long lines in 1989. Guests relived their pasts as they took in the sights and sounds of vintage arcade games, furnishings, signs, and even an old Oklahoma City streetcar. The decor remained largely intact until it was all sold at auction following the restaurant's closing in 2016. (Both, courtesy of the Oklahoma Historical Society.)

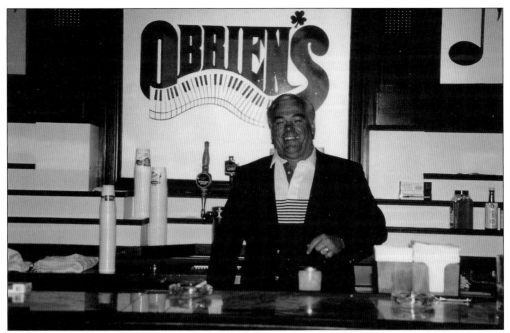

Jim Brewer opened O'Brien's shortly after the opening of Spaghetti Warehouse. Oklahoma City's younger residents were getting a glimpse of the diversions offered by an urban entertainment district without having to travel to Dallas's West End. (Courtesy of Brewer Entertainment.)

O'Brien's drew large crowds with new unique offerings, including karaoke and dueling piano players. The venue remained a popular draw for several years and continued as an annual pop-up karaoke bar at the Oklahoma State Fair through the early 2000s. (Courtesy of Brewer Entertainment.)

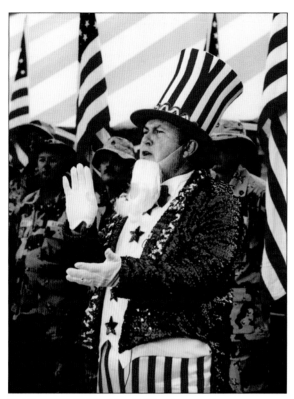

Bricktown made its first appearance on national television when Jim Brewer teamed up with KFOR-TV and hosted *The Today Show*'s Willard Scott for an early Fourth of July celebration that welcomed home troops returning in 1991 from Operation Desert Storm. (Courtesy of the Oklahoma Publishing Company.)

Jim Brewer (right) joins Gov. David Walters (left) and *Today Show* weatherman Willard Scott (center) in entertaining crowds gathered for a live national broadcast from Bricktown. The district was routinely featured on national television in future years, either during airings of *American Idol*, shows on the Food Network, and network airings of Oklahoma City Thunder basketball games. (Courtesy of Brewer Entertainment.)

India Temple clown Ken "Waddles" Young entertains along the route of the Oklahoma City Fourth of July Parade in Bricktown. The Shriners were featured performers in a celebration Jim Brewer turned into one of the district's biggest annual events. (Courtesy of the Oklahoma Publishing Company.)

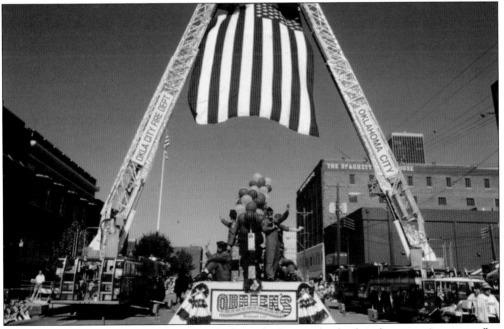

During the early Bricktown Fourth of July festivals, fire trucks displayed a giant American flag at the entrance to the district, as shown in this 1994 photograph. (Courtesy of the Oklahoma Publishing Company.)

Jim Brewer chose to recreate a water tower that once stood atop of the Red Ball Building as a way to promote Bricktown and O'Brien's and also draw some advertising revenue. For several years, the tower also was capped with the former Penn Square Bank clock sign. (Courtesy of Brewer Entertainment.)

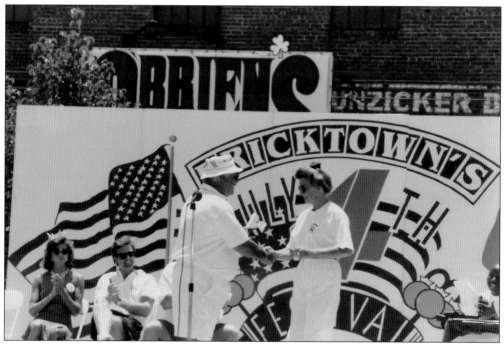

Jim Brewer often shared the stage with civic leaders, as he did with Oklahoma City's Ward 8 councilwoman Jackie Carrey at the 1991 Fourth of July celebration. (Courtesy of Brewer Entertainment.)

Bricktown's annual Fourth of July celebration grew into one of the city's biggest family attractions, offering a mix of circus and state fair entertainment with a healthy dose of patriotism and spectacle, capped with a fireworks show. (Courtesy of Brewer Entertainment.)

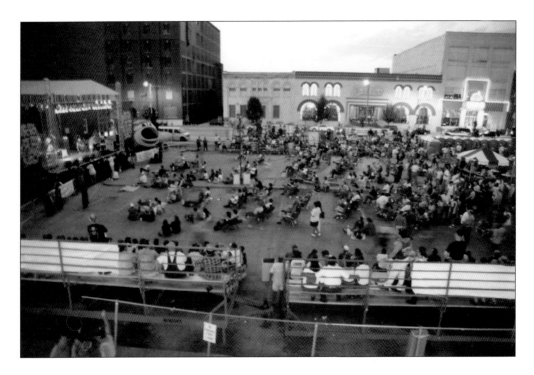

Jim Brewer, joined by sons Brent and Brett, launched a series of music festivals ranging from blues to reggae as they sought to brand Bricktown as a year-round destination. Brewer's sons have continued the legacy following Jim Brewer's passing in 2008. One of the most popular annual festivals is the Bricktown Blues and BBQ held each summer. (Both, courtesy of Brewer Entertainment.)

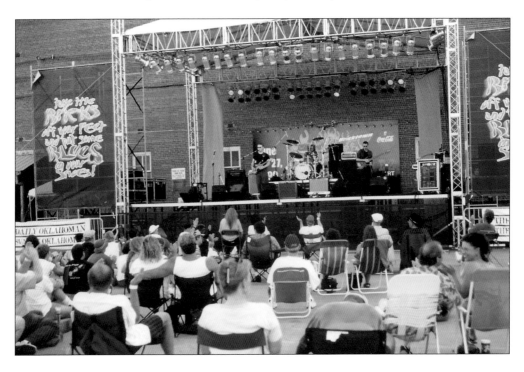

Three

BOOM

Aspiring restaurateurs wanted to copy the Spaghetti Warehouse success story and property owners who had survived the ups and downs of the 1980s. John Freeman, whose family owned the former home of the ABC Cab Company, converted the building into Piggy's Barbeque in 1981. The restaurant was small but successful, and in 1992, Freeman renovated two old warehouses next door into a larger home for the eatery. The McClain family, who operated Bunte Candy Co. in several warehouses along Sheridan Avenue, renovated the first two across from the Spaghetti Warehouse into two restaurants: Windy City Pizza and the Bricktown Brewery. A third building was redeveloped into the home of Abuelo's. The former Mideke Supply building was converted into a retail and antique mall.

Several restaurants opened and closed in just a matter of months. Spaghetti Warehouse continued to draw large crowds, and the Bricktown Brewery emerged as the district's first venue for live music. Bricktown was increasingly viewed as a symbol of downtown revival. Locals no longer needed to travel to Dallas's West End to experience urban fun. Restaurants, shops, and art galleries drew families during the day, and nightclubs drew younger visitors at night.

Jim Brewer's sons Brent and Brett opened their first venture, Rockabilly's, which boasted a high-tech video screen, 35-foot ceilings, murals, and a western dance floor. Bricktown Comedy Club opened, followed by Laff's and Jokers. By the end of 1992, the district was drawing an estimated 15,000 visitors a week. Marcelino "Chelino" Garcia followed Bricktown's growth for a year before deciding to add a third restaurant at 15 East California Avenue to his Oklahoma City chain.

Brewer was still promoting Bricktown, but he was no longer among a small minority of people interested in the district's future. Bricktown was a powerful draw. But a major city investment —MAPS, or Metropolitan Area Projects—was about to propel Bricktown to new heights.

"MAPS just kind of fell out of the sky, the people of Oklahoma City just don't know how lucky they are and what happened to them," Brewer said. "They better pinch themselves, because in four or five years, there is going to be no town in the Southwest as great as this one."

John Freeman decided to move his Piggy's Barbeque to a larger, more prominent location in Bricktown after seeing the steady flow of customers at Spaghetti Warehouse. Freeman combined two buildings at 303 and 309 East Sheridan Avenue, spent $1 million on renovations, and created a tribute to Dixieland jazz in a building designed to resemble a turn-of-the-20th-century tavern. (Both, courtesy of the Oklahoma Historical Society.)

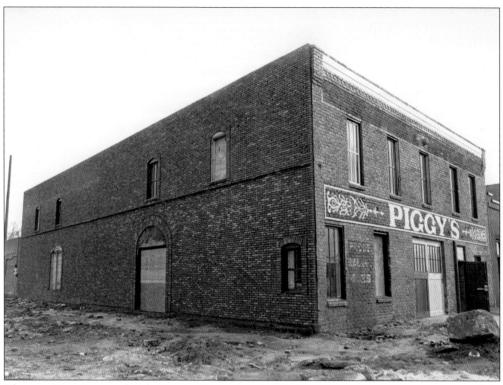

The new Piggy's opened with Dixieland jazz played nightly in a restaurant decor consisting of old railroad timbers, old stained glass, boxcar siding, wood paneling, and bars from the city's original 1890 territorial jail. The restaurant expanded its hours and remained popular until the building was sold to Pearl's Crabtown. (Both, courtesy of the Oklahoma Historical Society.)

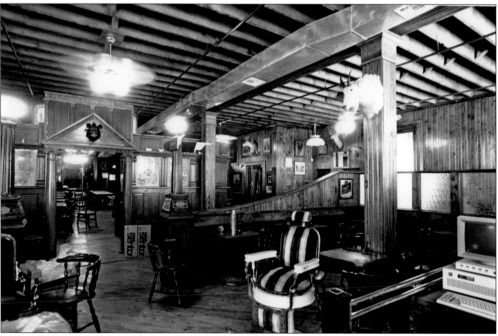

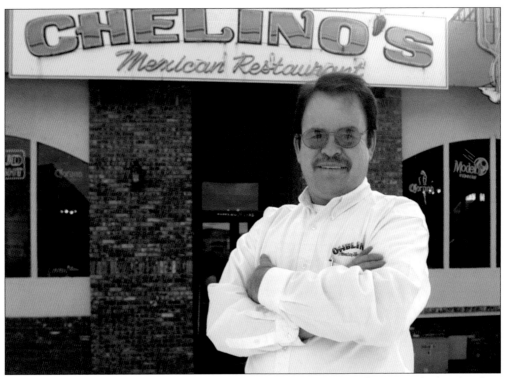

Marcelino Garcia observed restaurant activity in Bricktown for more than a year before deciding to open a third location for his Chelino's Mexican Restaurant at 15 East California Avenue. His restaurant was a hit with locals and visitors and the first to be open with patios facing the Bricktown Canal several years later. (Both, courtesy of the Oklahoma Historical Society.)

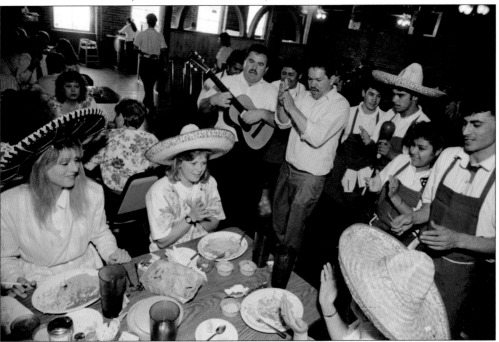

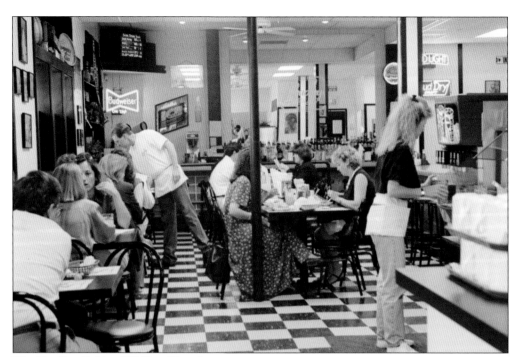

The Bradley Café at 201 East Sheridan Avenue was opened by Bill Vetter and his son Brian, who sought to re-create the feel of a store by the same name in Blackwell. The Bricktown restaurant's homey, small-town atmosphere was coupled with a menu that boasted the Bradley Burger, a half-pound of meat, sourdough bread, bacon, and mozzarella cheese. (Courtesy of the Oklahoma Historical Society.)

Bricktown Harleys Bar & Grill, 1 East California Avenue, was opened by Chance Leonard, John Basso, and Bryan Rops in April 1993. The menu featured buffalo burgers, hamburgers, and assorted finger foods and beverages but was better known for a fight that took place between actor Jim Belushi and a fan upset over not getting an autograph. (Courtesy of the Oklahoma Historical Society.)

One of the earliest Bricktown merchants, Cheryl Ishmael, in 1992 renovated the former home of Mideke Supply into a gift shop, Bricktown Mercantile. The two-story gift shop and antique mall helped mold Bricktown into a visitor destination, even though more than half of the buildings were still vacant and several remained boarded up and abandoned. (Both, courtesy of the Oklahoma Historical Society.)

Deena Palmer and her husband, Orville, spent a decade visiting art galleries in New Mexico before deciding to open their own frame shop and art gallery at 101 East Sheridan Avenue in Bricktown. Their displays included Edmond resident Russell Cooper's rodeo portraiture, paintings of golfers, and a collage of baseball memorabilia in poster-art style, as well as a contemporary version of the Native American designs of artist Robert Sisk's heritage. (Both, courtesy of the Oklahoma Historical Society.)

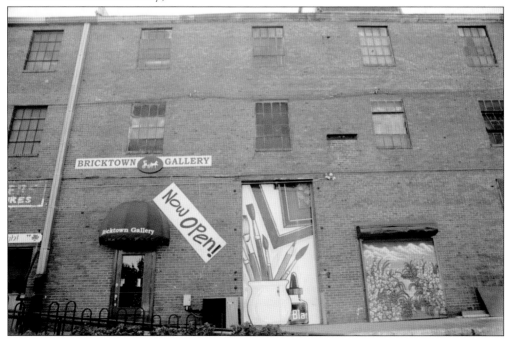

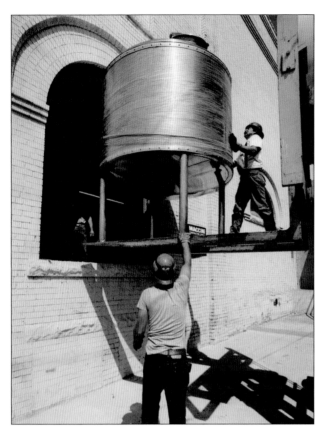

Brewery restaurants were newly legal in Oklahoma when plans ramped up for the Bricktown Brewery. Delivery of huge tanks was the talk of the town, and the operation of the brewery, viewable to customers, made for a unique restaurant and bar experience for visitors. The brewery was also a popular live music venue that featured billiard tables and a second bar upstairs. (Both, courtesy of the Oklahoma Historical Society.)

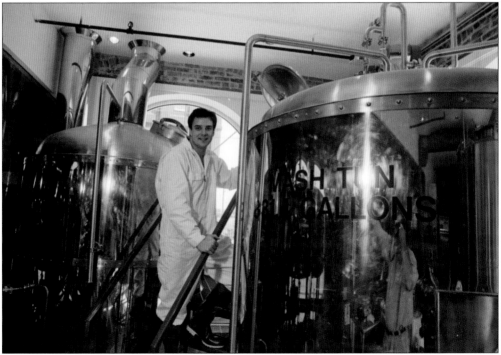

Four

BASEBALL AND WATER TAXIS

Oklahoma City started the 1990s with momentum, but it was also still dogged with poor self-esteem. A new mayor, Ron Norick, won voters' support for a series of tax initiatives aimed at luring new industry; however, despite the best of incentives packages, Oklahoma City was repeatedly rejected. He visited Indianapolis after that city won the competition for a new airline maintenance plant. He saw a vibrant downtown and a city that took pride in itself. He returned home with renewed enthusiasm to get Oklahoma City to reinvest in itself. His timing was good – veteran advertising man Ray Ackerman was leading a similar discussion as chairman of the Greater Oklahoma City Chamber. The resulting vision was the Metropolitan Area Projects, which called for multiple projects downtown, including a riverwalk-style canal and a vintage-style ballpark in Bricktown. The proposition was passed, but not before founder Neal Horton died from emphysema. Horton had never recovered from his failure in Bricktown, and in the months leading up to his death, he was destitute and, at one point, homeless.

The Metropolitan Area Projects, or MAPS, proceeded at a turtle pace that frustrated the public. Early bids came in over budget and timelines were slipping. The ballpark was to be the first project built, and when it opened in 1998, the ceremonies were attended by some of the greatest names in baseball. The ballpark won rave reviews from the public.

The canal was built along California Avenue, and construction required excavation at basement level of some of the city's oldest buildings. More than 60,000 people attended the grand opening on July 2, 1999, triggering a new wave of building renovations and business openings that would continue through the next century. Bricktown was growing into a regional destination and expanding east, north, and south. Horton's vision was coming true.

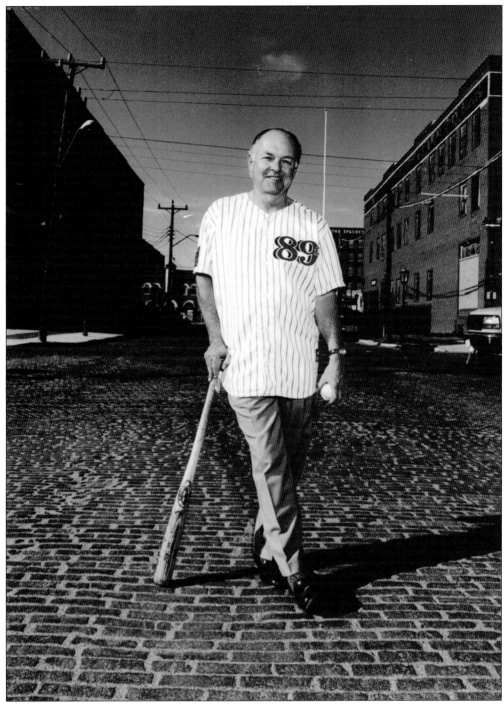

Mayor Ron Norick, determined to reverse years of economic decline and stagnation in Oklahoma City, spent 1993 pitching a plan that would ask voters to invest in their community. Wearing an 89ers baseball jersey, Norick's successful initiative, MAPS, called for construction of a new ballpark in Bricktown along with a San Antonio–style riverwalk to be known as the Bricktown Canal. (Courtesy of the Oklahoma Publishing Company.)

Jim Brewer and several fellow property owners and merchants were eager supporters of MAPS and helped host a rally for the December 1993 election that included marching bands, local celebrities, and a vast display of the city's diverse population. (Both, courtesy of the Oklahoma Historical Society.)

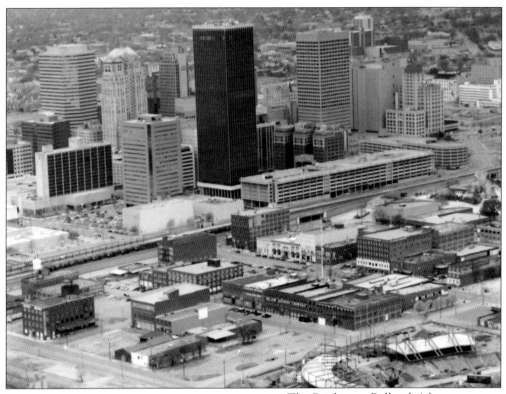

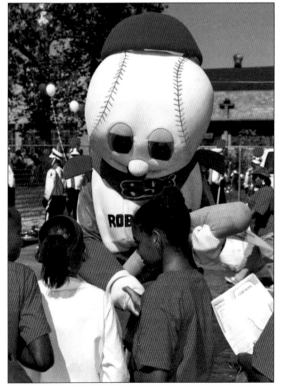

The Bricktown Ballpark (also known throughout the years as the Southwestern Bell or Chickasaw Bricktown Ballpark) was the first MAPS project built, as shown in this 1997 photograph. The ballpark was immediately adjacent to some of Bricktown's most desolate streets, but that soon would change with construction of the Bricktown Canal along California Avenue. (Courtesy of Brewer Entertainment.)

Roboniner, the mascot for the 89ers, made one of its last appearances in Bricktown during the ground breaking for the ballpark. The team's mascot was retired, and the team's name was changed to the RedHawks shortly before the ballpark's opening in April 1998. (Courtesy of the Oklahoma Publishing Company.)

The opening of the Bricktown Ballpark in 1998 drew thousands and marked a shift in community self-esteem. A public that had grown skeptical about MAPS due to cost overruns and schedule delays turned positive as they saw a ballpark they concluded was going to help change the city's direction. (Courtesy of the Oklahoma City Dodgers.)

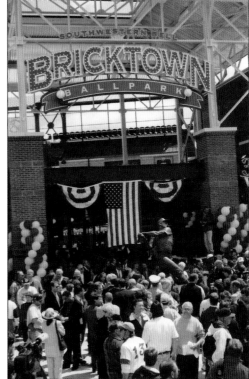

From left to right, former New York Yankee greats Bobby Murcer, Yogi Berra, and Whitey Ford were reunited at the dedication of a statue of another Yankee great, Mickey Mantle, at the opening day festivities at the Southwestern Bell Bricktown Ballpark. (Courtesy of the Oklahoma Publishing Company.)

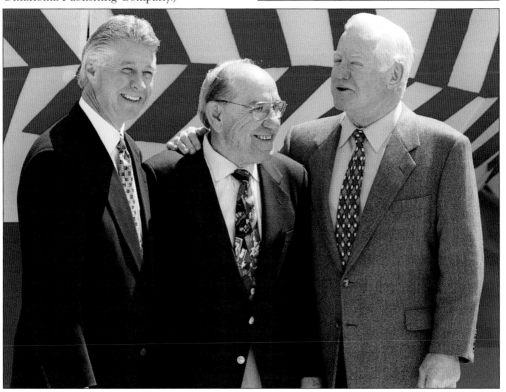

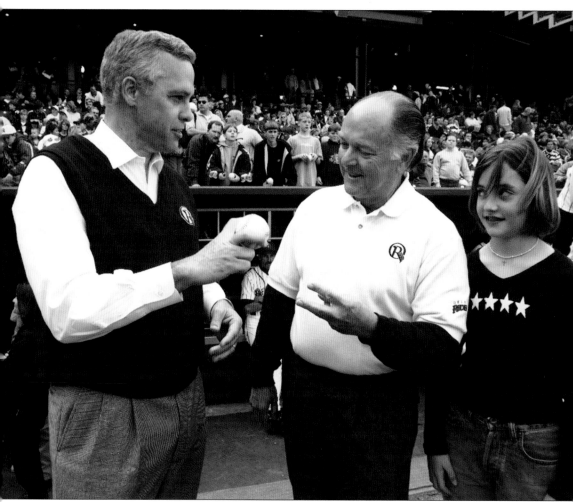

Newly elected mayor Kirk Humphreys (left) shares tips on the first pitch with Mayor Ron Norick (center) and Norick's daughter Emily Taylor (right). The opening of the Bricktown Ballpark in April 1998 marked a transition from Norick, who envisioned MAPS and got it started, to Humphreys, who oversaw efforts to solve funding and ensured all the projects were finished as promised. (Courtesy of the Oklahoma Publishing Company.)

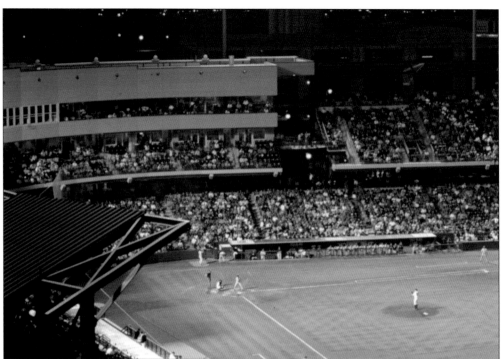

The new Bricktown Ballpark brought new life to the city's minor league baseball team, drawing thousands game after game. The ballpark featured modern concession stands, private suites, a kids' play area, and cutting-edge large screen video boards. (Courtesy of the Oklahoma Publishing Company.)

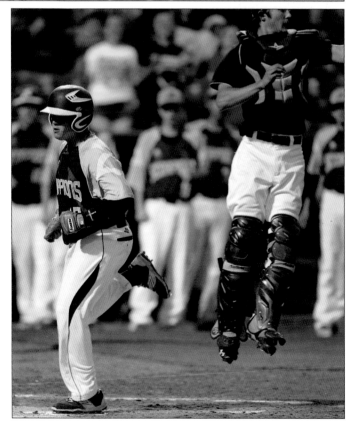

Boswell's Connor Roberts runs home past Tanner White of Lookeba-Sickles in the third inning of the Class B state baseball championship game at Bricktown. (Courtesy of the Oklahoma Publishing Company.)

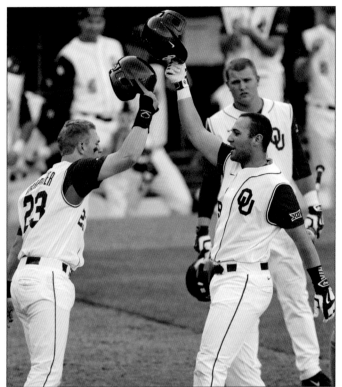

The University of Oklahoma's Anthony Hermelyn (right) celebrates his two-run home run with Kolbey Carpenter in the seventh inning of a Bedlam baseball game between the University of Oklahoma Sooners and the Oklahoma State Cowboys at the Bricktown Ballpark. (Courtesy of the Oklahoma Publishing Company.)

Oklahoma City RedHawks player Brett Wallace watches mascot Ruby ride a motorcycle before the 2012 opening day baseball game. Ruby and fellow mascot Rowdy were retired in 2014 when the team was renamed the Oklahoma City Dodgers. (Courtesy of the Oklahoma Publishing Company.)

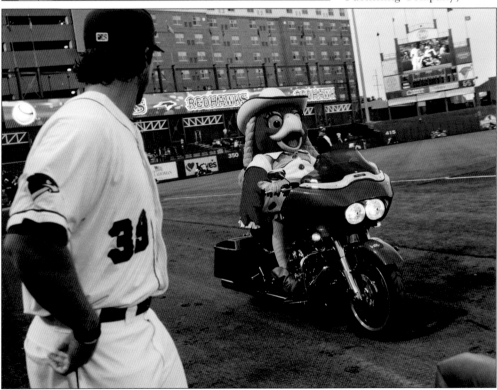

At right, baseball legends Johnny Bench (left) and George "Sparky" Anderson (right) pose for pictures in front of the Johnny Bench statue at the Bricktown Ballpark. Bench is one several native Oklahomans in the National Baseball Hall of Fame who are honored at the Bricktown Ballpark. Below, Bench signs autographs at the ballpark for fans. (Both, courtesy of the Oklahoma Publishing Company.)

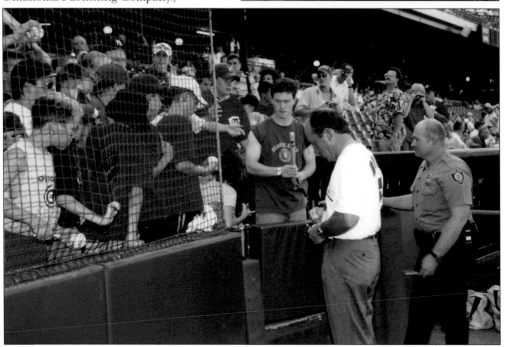

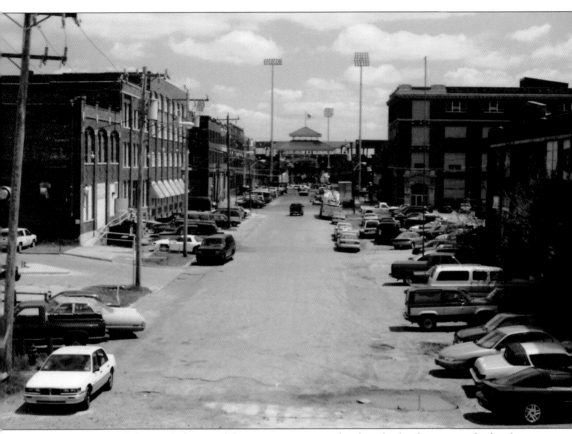

Not much had changed along California Avenue over the decades leading up to the brick street being torn up to make way for a canal. Several of the buildings were empty when this photograph was taken in 1997. (Courtesy of the City of Oklahoma City.)

A short-lived Bricktown mascot, Mr. Brick, was among the dozens who showed up for a ground breaking for the Bricktown Canal in 1998. The canal represented a break from Oklahoma City history—a public works project that was purely recreational in nature, designed to entertain both locals and draw visitors. (Both, courtesy of the Oklahoma Historical Society.)

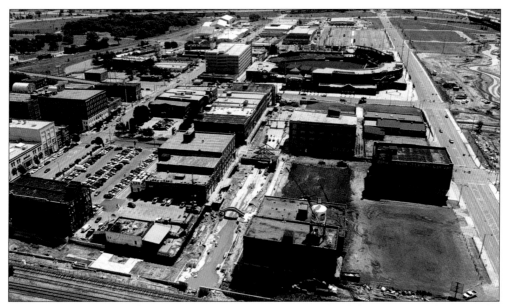

Construction of the Bricktown Canal required excavation of California Avenue between the BNSF Railway viaduct and Walnut Avenue (later renamed Mickey Mantle Drive). The excavation exposed basement levels of century-old buildings with the intent of creating a two-level walkway, with one at street level and the other at the canal level with the hope of drawing basement-level retail. (Courtesy of the Oklahoma Publishing Company.)

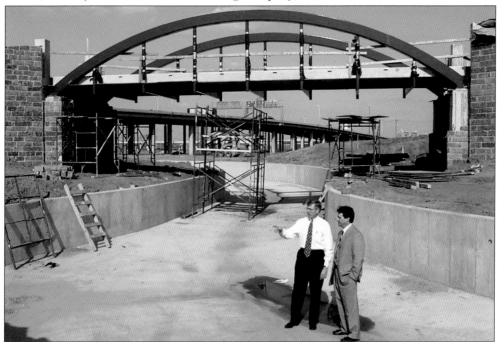

Engineers Dennis Clowers (left) and Tim Johnson (right) are pictured in the future canal where it would be surrounded by a more parklike setting south of Interstate 40. Clowers designed the south half of the canal, while Johnson designed the more urban north half of the canal. (Courtesy of the Oklahoma Publishing Company.)

Some entrepreneurial restaurateurs attempted to beat the rush and open for business, even as the Bricktown Canal was under construction and hampered access to adjoining buildings. Larry Miller opened My Place Restaurant and Bar hoping construction workers would keep him in business until the canal opened. The restaurant, however, was closed by the July 1999 canal opening. (Courtesy of the Oklahoma Publishing Company.)

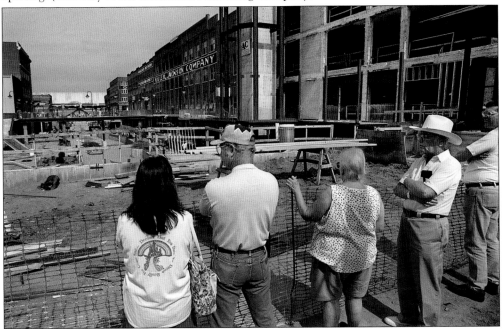

Public interest in the Bricktown Canal grew as the waterway emerged. Contractors created a viewing stand for crowds to safely watch work under way, though in the final weeks prior to the opening, thousands trespassed the job site, wanting to get a closer look. (Courtesy of the Oklahoma Publishing Company.)

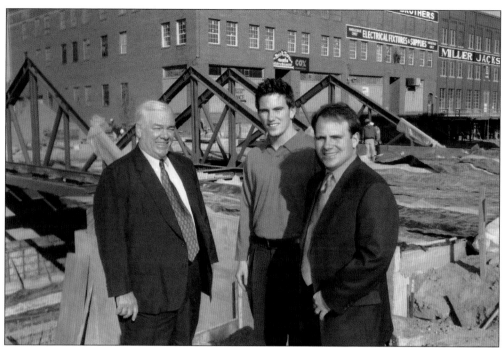

From left to right, Jim Brewer and his sons Brett and Brent stop along the new Oklahoma Avenue bridge during their visit to the Bricktown Canal. In the late 1990s, the Brewers were the largest single property owners along the future waterway. (Courtesy of Brewer Entertainment.)

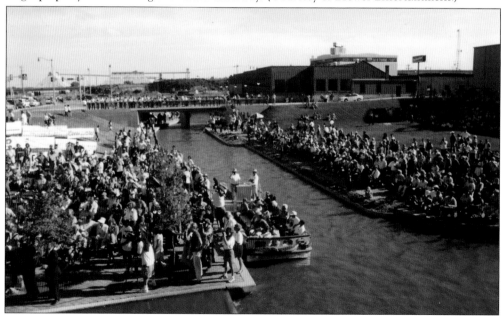

Up to 200,000 visited the Bricktown Canal during its opening weekend on July 2, 1998. Canal opening festivities, combined with the annual Fourth of July celebration, drew media coverage from across the state, with state and local dignitaries lining up to connect themselves to a project once questioned as frivolous but greeted as a success story. (Courtesy of the Oklahoma Publishing Company.)

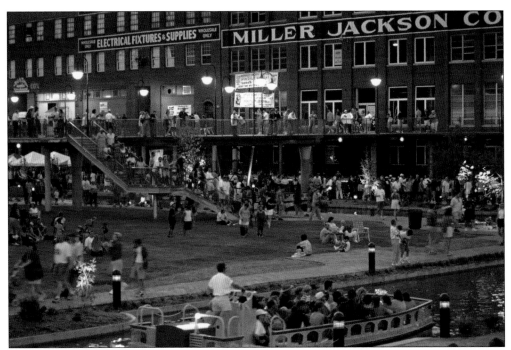

Lines formed early and stayed for hours to enjoy the first water taxi rides along the new Bricktown Canal. Visitors arrived from throughout the state to see for themselves the canal and enjoy what was, at the time, called a "boat ride to nowhere" due to the lack of development on the south half of the waterway. (Courtesy of the Oklahoma Publishing Company.)

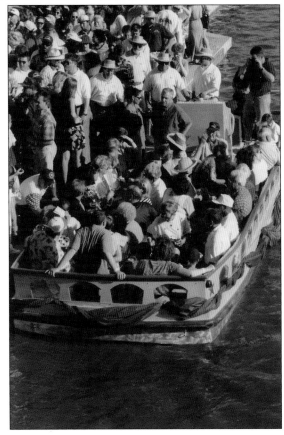

Mayor Kirk Humphreys and fellow city council members board a water taxi for the inaugural ride along the Bricktown Canal on July 2, 1999. (Courtesy of the Oklahoma Publishing Company.)

The success of the Bricktown Ballpark and the Bricktown Canal generated a new wave of development in the entertainment district and interest in building housing in adjoining Deep Deuce. Preservationists fought with city engineers over whether the crumbling but historic bridge connecting the two areas should be rebuilt or replaced with a less iconic street-level rail crossing. Ultimately, the preservationists won by taking the dispute to the Oklahoma Corporation Commission. (Both, courtesy of the Oklahoma Publishing Company.)

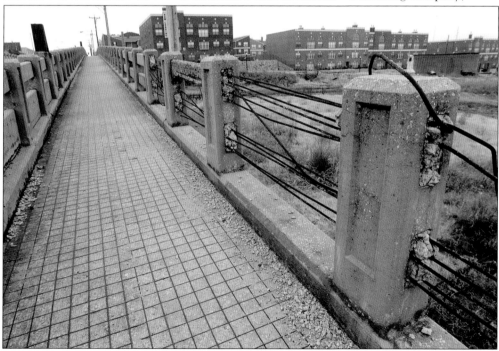

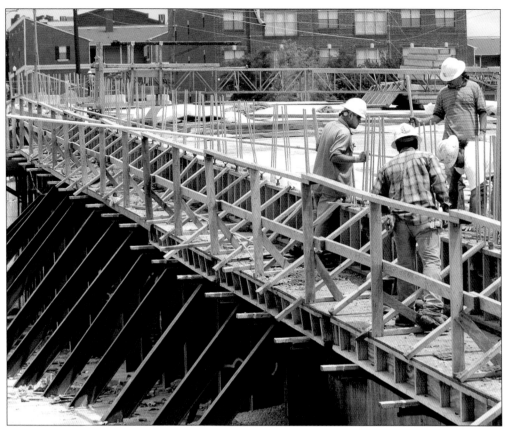

Crews completely rebuilt the Walnut Avenue Bridge, and it is once again an iconic crossing that is often used as a dramatic start or finish to marathons and walks. The bridge now connects Bricktown with an equally thriving Deep Deuce. (Both, courtesy of the Oklahoma Publishing Company.)

Construction along the Bricktown Canal continued for months after its opening in 1999. Some property owners arranged to have extended patios built during the canal's construction, while others, like Jim Brewer, did not finalize plans for their patios until later. Brewer created two

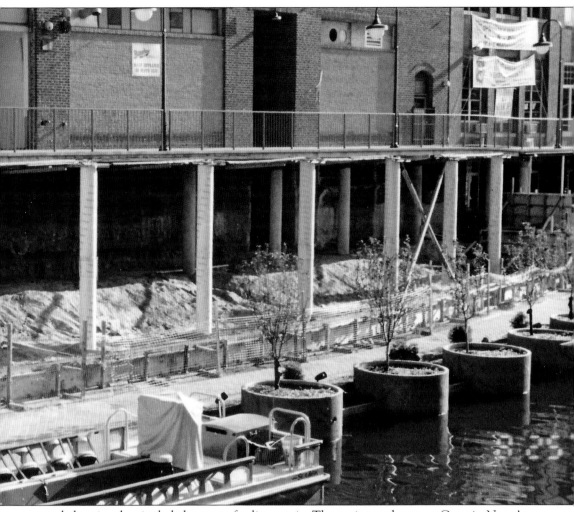

extended patios that included a space for live music. The patio was home to Captain Norm's Dockside Bar in 2016. (Courtesy of Brewer Entertainment.)

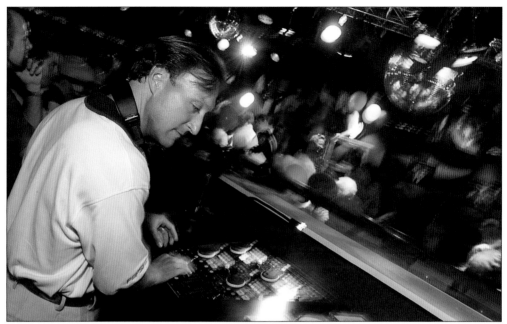

D.J. Wally Kerr plays some dance music for a large crowd on the dance floor at Bricktown 54, a popular nightclub during the early 2000s that combined modern entertainment with 1970s disco. The nightclub operated with an outdoor patio on the rooftop of the JDM Building. (Courtesy of the Oklahoma Publishing Company.)

CityWalk was Bricktown's most popular nightclub during the early 2000s. The multi-venue night club, spread out over 30,000 square feet in the Mideke Building at 100 East Main Street, was the only venue to feature multiple themes under one roof, at times including a country-western club, dueling piano bar, wine bar, and a comedy club. At the time it closed, it included a disco, modern music dance hall, karaoke bar, live band room, and martini lounge. (Courtesy of the Oklahoma Publishing Company.)

Five

THE NEW MILLENNIUM

The opening of the ballpark and canal sparked a wave of new restaurants and shops with an estimated three million people visiting Bricktown as of 1999. The opening of the ballpark initially posed a quandary for city leaders as they weighed initial plans for parking along the canal south of Reno Avenue, with developers wanting to build restaurants, shops, and entertainment.

The concerns over parking for the ballpark were eased with construction of a 553-space garage. Between 2000 and 2007, Hogan developed Lower Bricktown with a mix of various businesses and housing, including a 16-screen theater, shops, restaurants, hotel, bowling lounge, a Bass Pro Shop, 30 condominiums, and a national headquarters for Sonic Drive-Ins.

Bricktown has drawn visitors such as New York City mayor Rudy Giuliani, movie star Matt Damon, recording artists Vince Gill and wife Amy Grant, Steven Tyler, Paul McCartney, movie producer Steven Spielberg, and actors Nick Offerman, Megan Mullally, and Holly Hunter. The ballpark has enticed legends from the first day it opened, including Johnny Bench, Sparky Anderson, Yogi Berra, Bobby Mercer, Whitey Ford, and, later, Joe Carter and Tommy Lasorda. The arrival of the NBA, meanwhile, added Kevin Durant, Chris Paul, James Harden, and LeBron James to the list of Bricktown celebrity guests.

Attention, meanwhile, turned to buildings that had been virtually abandoned during the first 25 years of Bricktown's emergence as an entertainment district. Buildings empty for 20 years or longer, including the Kingman and Rock Island Plow, were renovated into offices and restaurants.

Bricktown's status as a tourist destination was enhanced with construction of several hotels. Brickopolis, a three-story arcade, miniature golf course, burger bar, and pizza buffet, combined with the canal's water taxis as a strong draw for families. In 2015, Bricktown expanded east into the former home of Stewart Metal Fabricators. Construction of the Steelyard included two hotels, 400 apartments, and 26,000 square feet of retail. Across the street, The Criterion music hall opened in 2016 to rave reviews while construction was under way on one of three more hotels.

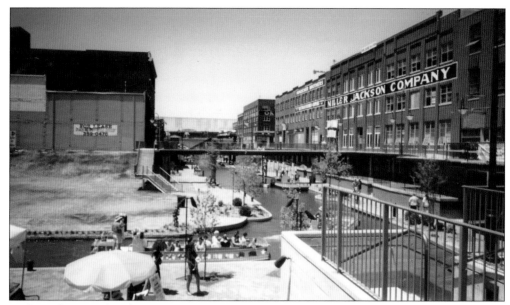

In the early years after the opening of the Bricktown Canal, visitors had to imagine what it might look like in future years. The landscaping barely made an impression, and most buildings were in various stages of development. (Courtesy of the Oklahoma Publishing Company.)

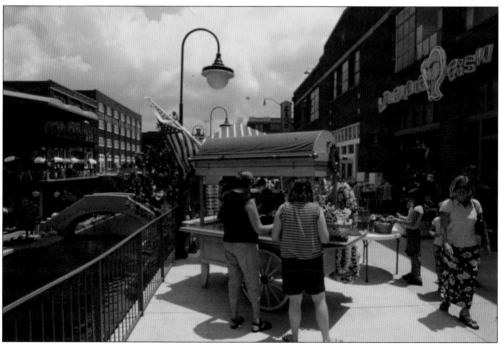

The Laughing Fish was one of the first attempts at retail along the Bricktown Canal. Shoppers were offered a selection that ranged from gifts to party dresses, and during decent weather, outdoor kiosks were set up to expand the store's selection. (Courtesy of the Oklahoma Publishing Company.)

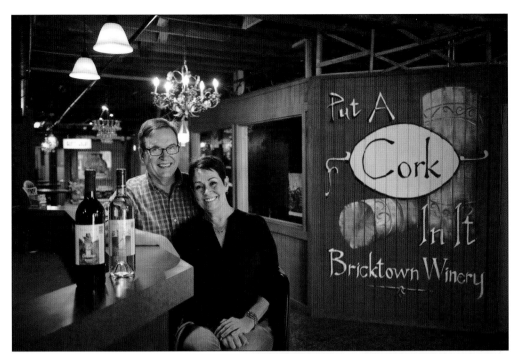

John and Andrea Burwell opened Put a Cork In It Winery in the canal level of the renovated Miller Jackson Building and quickly earned a loyal following of customers for wine made and labeled on the premises. The pair expanded their operation in future years to include a gift shop and a wine and art room. (Courtesy of the Oklahoma Publishing Company.)

The success of the Bricktown Canal attracted a variety of street performers ranging from midway-style acts to musicians, to people dressing up as cartoon and superhero characters. Here, "Orange Rex" performs for Bricktown visitors. (Photograph by Michael Downs.)

Festivals started by the Brewer family over the years include Bricktown Blues and BBQ, Bricktown Reggaefest, Bricktown Fourth Fest, and others like Germanfest, which were discontinued but not without creating some fond memories among those who enjoyed the mix of German food,

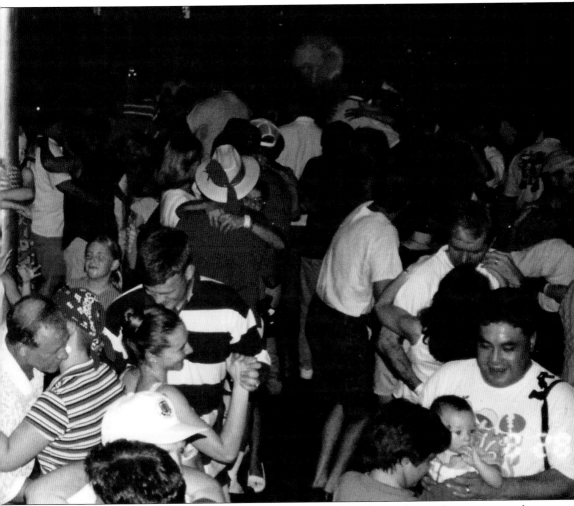

music, and beer. The festivals were typically held in the parking lot at the southwest corner of Oklahoma and Sheridan Avenues—a property set to be redeveloped into a parking garage with ground-floor retail in 2016. (Courtesy of Brewer Entertainment.)

DeadCENTER Film Festival grew into a major national celebration of independent filmmaking as downtown venues grew to include the Harkins Theatres in Bricktown. (Courtesy of the Oklahoma Publishing Company.)

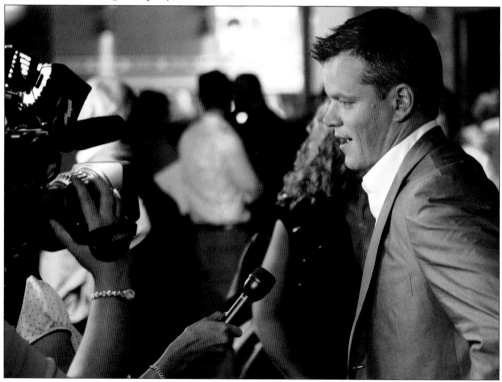

Movie start Matt Damon is among the celebrities who have attended film showings at Harkins Theatres. Damon attended the July 31, 2007, Oklahoma City premiere of *The Bourne Ultimatum* with producer Frank Marshall as part of a benefit for the Children's Center. (Courtesy of the Oklahoma Publishing Company.)

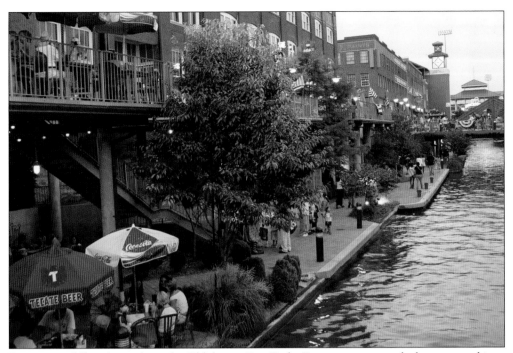

Decent rainfall and care from the Oklahoma City Parks Department turned a barren canal into a green urban oasis within just a few years after the Bricktown Canal's 1999 opening. (Courtesy of the Oklahoma Historical Society.)

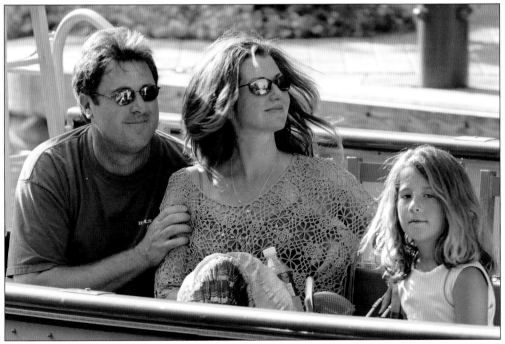

Oklahoma City celebrities who have visited Bricktown include husband-and-wife singers Vince Gill and Amy Grant and their daughter Corrina Grant Gill. (Courtesy of the Oklahoma Publishing Company.)

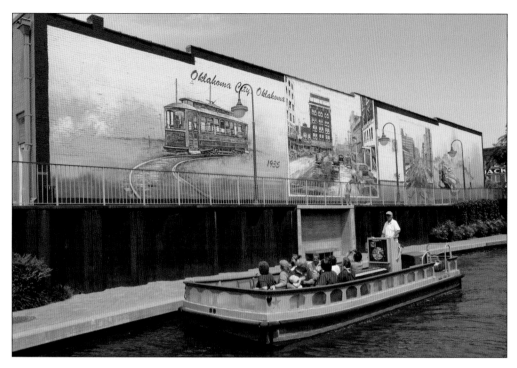

Artist Bob Palmer and his students at the University of Central Oklahoma created some of the most memorable murals in Bricktown, including re-creation of postcards depicting downtown Oklahoma City in the mid-1900s and a blocks-long mural of an 1800s train along the BNSF Railway viaduct, featuring local celebrities and civic leaders. (Both, courtesy of Bob Palmer.)

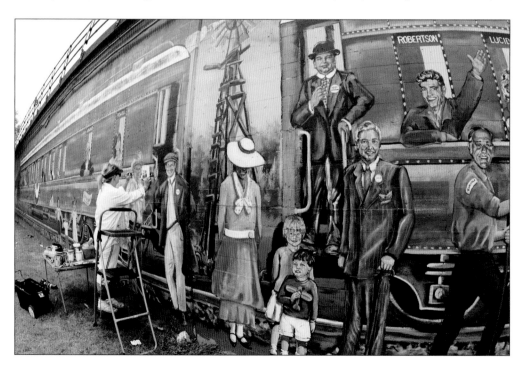

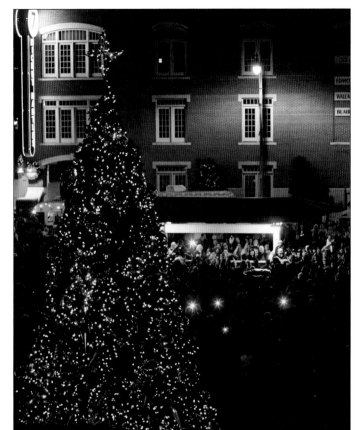

The lighting of a large Christmas tree and the decorations along the Bricktown Canal have emerged as an annual holiday tradition for locals who bring their families to Bricktown to also enjoy snow tubing at the Bricktown Ballpark. (Both, courtesy of the Oklahoma Publishing Company.)

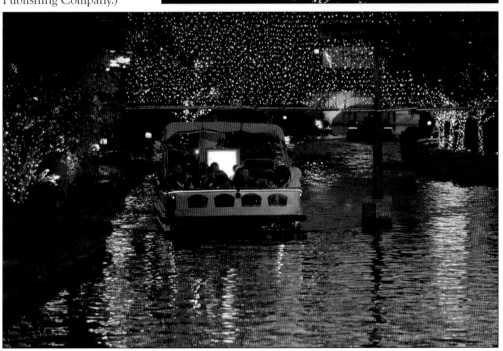

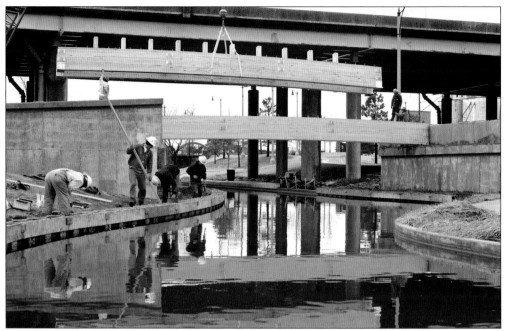

Developer Randy Hogan extended Bricktown south of Reno Avenue with construction of Lower Bricktown, a mix of shops, restaurants, and condominiums. The development included construction of new bridges, sidewalks, and other amenities along the Bricktown Canal. (Courtesy of the Oklahoma Publishing Company.)

Construction of the Centennial, just south of Reno Avenue, included the first significant addition of housing to Bricktown, along with a bowling lounge, restaurants, and a Starbucks. (Courtesy of the Oklahoma Publishing Company.)

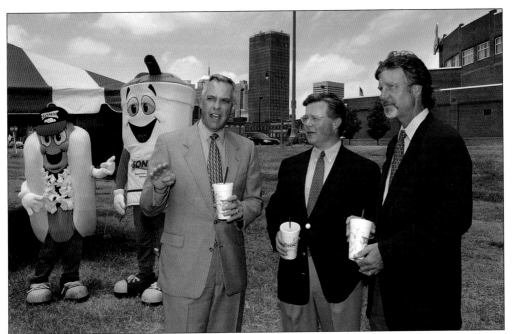

Oklahoma City–based Sonic chose to build its new headquarters in Lower Bricktown. Sonic mascots joined, from left to right, Mayor Kirk Humphreys, Sonic chief executive officer Cliff Hudson, and developer Randy Hogan at the ground breaking. (Courtesy of the Oklahoma Publishing Company.)

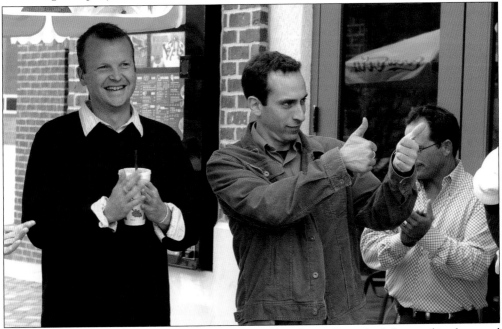

The stars of Sonic's commercials, TJ Jagodowski (left) and Pete Grosz (right), joined in the grand opening for the Bricktown Sonic Café in Lower Bricktown. The café, next to the new Sonic headquarters, is one of the few freestanding Sonics without carhop service. (Courtesy of the Oklahoma Publishing Company.)

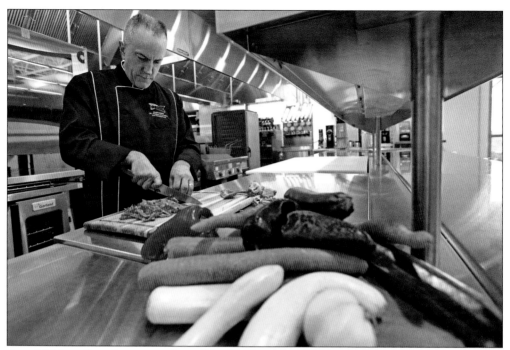

Scott Uehlein, Sonic's vice president of Product Innovation and Development at the Sonic Drive-In Corporate Campus, oversees operations at the company's test kitchen in Lower Bricktown. (Courtesy of the Oklahoma Publishing Company.)

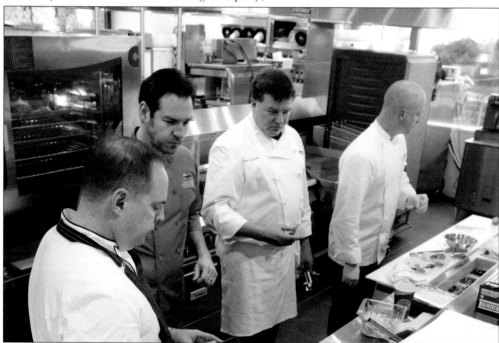

From left to right, chefs John Draz, Trevor Wilson, Mark Sobczak, and Brian McKinney brainstorm on culinary ideas at Sonic Drive-In's test kitchen at its Bricktown headquarters. (Courtesy of the Oklahoma Publishing Company.)

Toby Keith signs the blouse of Brenda Smithson after helping break ground on his theme restaurant, Toby Keith's I Love This Bar and Grill, in Lower Bricktown. (Courtesy of the Oklahoma Publishing Company.)

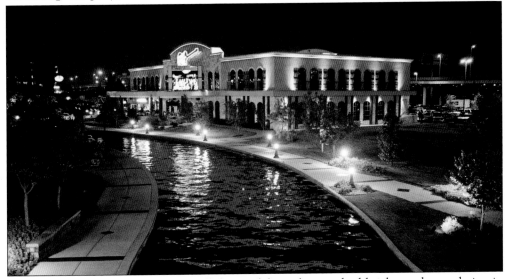

Toby Keith's I Love this Bar and Grill deviated from the standard brick warehouse design in Bricktown and instead featured a rock and stone facade, along with a less-urban approach to its patio and connection to the canal's walkways. (Courtesy of the Oklahoma Publishing Company.)

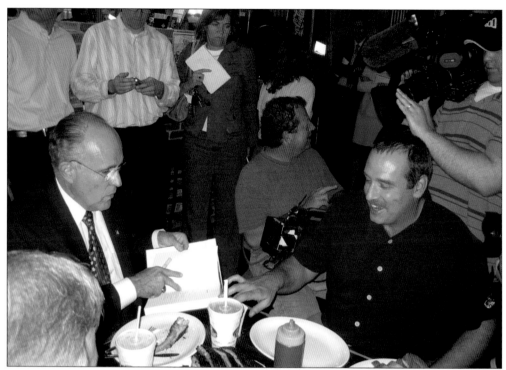

Bricktown is a frequent stop for presidential candidates, including Rudy Giuliani, who enjoyed a lunch and signed copies of his book at Earl's in Lower Bricktown, and Ted Cruz, who held a rally at the Chevy Bricktown Event Center. Bricktown also hosted a daylong live broadcast of MSNBC's 2016 presidential primary coverage. (Both, courtesy of the Oklahoma Publishing Company.)

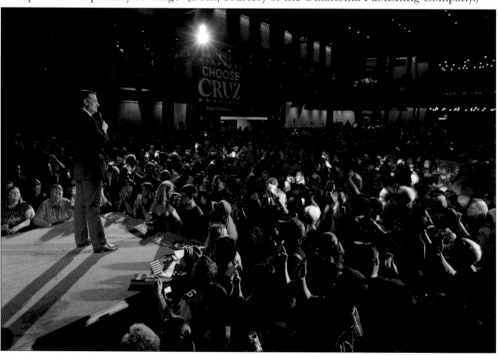

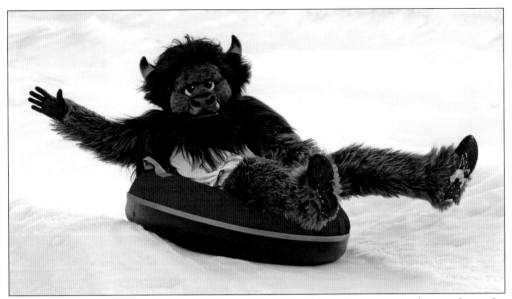

Rumble the Bison, mascot for the Oklahoma City Thunder, enjoys a snow tube run down the stands of the Bricktown Ballpark. Snow tubing is an annual holiday draw for Bricktown. (Courtesy of the Oklahoma Publishing Company.)

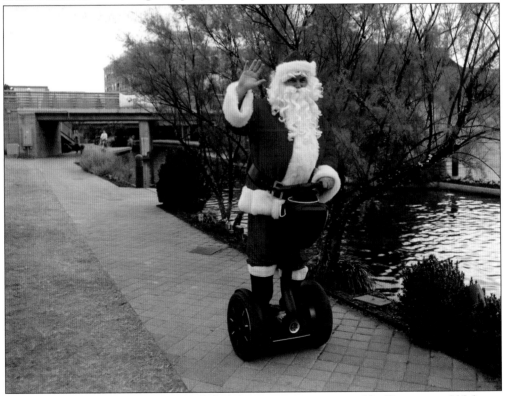

"Segway Santa" is one of several yearly holiday attractions organized by Downtown Oklahoma City Inc., which operates Bricktown's business improvement district. (Courtesy of the Oklahoma Publishing Company.)

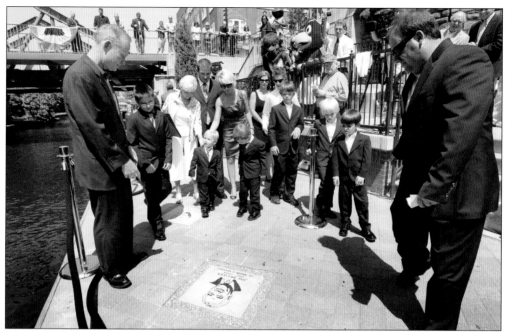

Jim Brewer died in 2008, and a year later, the district chose to honor Brewer and Bricktown founding father Neal Horton, who died in 1992, with memorial pavers along the Bricktown Canal. Oklahoma City mayor Mick Cornett joined with Brewer's family in honoring the district pioneer at a 2009 ceremony. (Courtesy of the Oklahoma Publishing Company.)

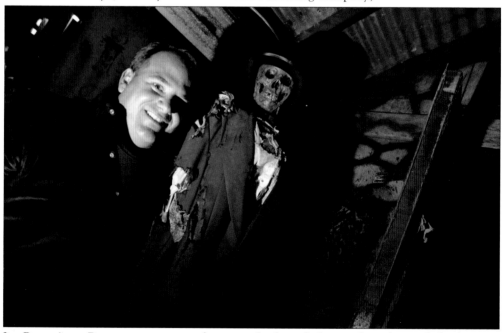

Jim Brewer's son Brent was a teenager whose own fondness for haunted warehouses helped inspire the launching of the Bricktown Haunted Warehouse. Brent Brewer, shown with one of his ghoulish friends, continued to operate the yearly attraction with his brother Brett after the death of their father. (Courtesy of the Oklahoma Publishing Company.)

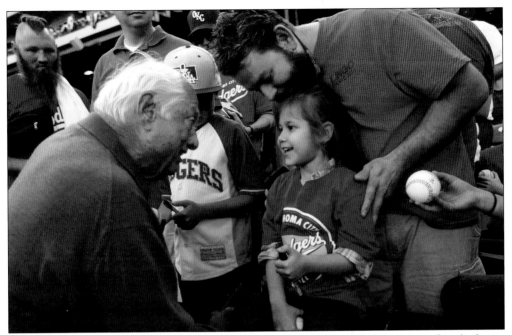

The Los Angeles Dodgers bought the RedHawks in 2014, renamed the operation after the home team, and introduced Oklahoma City baseball fans to Dodger legend Tommy Lasorda. During one of the first games, Lasorda visited with fans Abigail Bise (age 5) and Robert Bise. (Courtesy of the Oklahoma Publishing Company.)

Mascot Brix leads fans in the chicken dance between innings during a minor-league baseball game between the Oklahoma City Dodgers and the Colorado Springs Sky Sox at the Chickasaw Bricktown Ballpark. (Courtesy of the Oklahoma Publishing Company.)

A fireworks show is often included as postgame entertainment at the Bricktown Ballpark. The glow of the fireworks makes for a spectacular backdrop for the ballpark's Mickey Mantle statue. (Courtesy of the Oklahoma Publishing Company.)

Fire department history and one of the city's original fire trucks is on display for visitors to the Bricktown Fire Station at Lincoln Boulevard and Sheridan Avenue. A historic display of the police department's history can be viewed at the Bricktown Police Substation at 219 East Main Street. (Courtesy of the Oklahoma Publishing Company.)

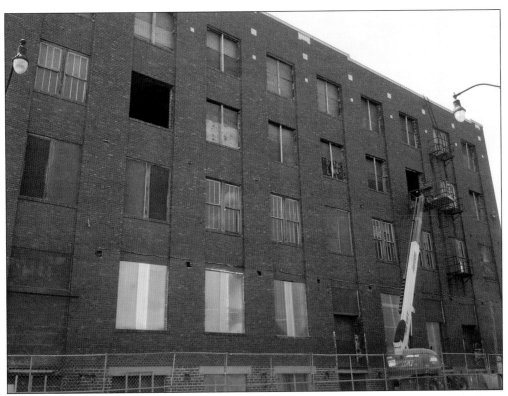

The Rock Island Plow Building, 29 East Reno Avenue, was boarded up for more than 30 years before it was targeted for renovation by developer Richard McKown and architect Wade Scaramucci. The building's wood floors had deteriorated badly and had to be gutted for the structure to be saved. (Both, courtesy of the Oklahoma Publishing Company.)

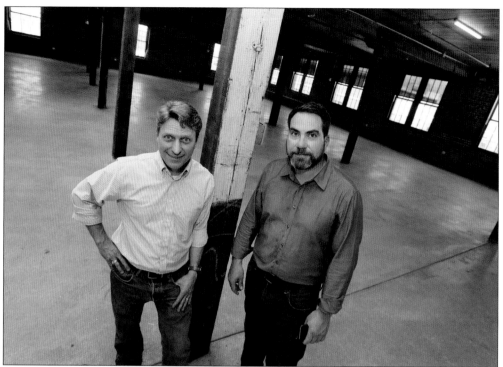

Developer Richard McKown (left) and architect Wade Scaramucci (right) celebrate a successful restoration of the Rock Island Plow Building, which included adding it to the National Register of Historic Places. Floors were raised to better match up with windows, and much of the building's 160-year-old timber was reused in the redevelopment. (Both, courtesy of the Oklahoma Publishing Company.)

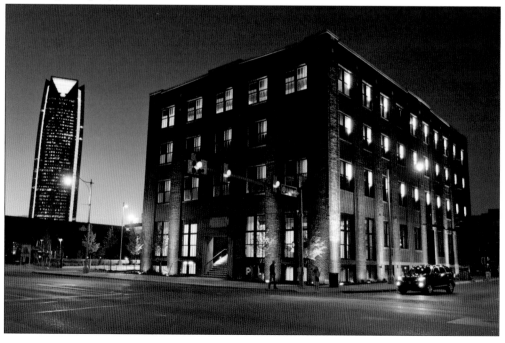

Developer Chris Johnson acquired two key properties along the Bricktown Canal just west of the ballpark and built Brickopolis, a three-story arcade, restaurant, gift shop, and miniature golf course. The attractions are credited with creating a new vibrancy along the lower canal level. (Both, courtesy of the Oklahoma Publishing Company.)

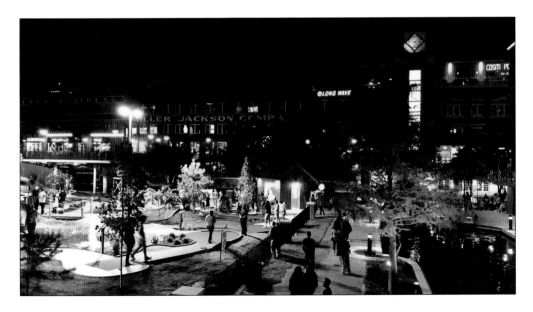

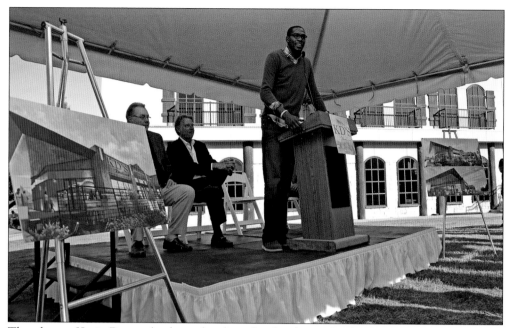

Thunder star Kevin Durant (at the podium) is a familiar face in Bricktown. He joined restaurateur Hal Smith (left) and developer Randy Hogan (center) in breaking ground for a restaurant in Lower Bricktown that celebrates his career. Durant also attended a premiere for his film *Thunderstruck* at Harkins Theatres. (Courtesy of the Oklahoma Publishing Company.)

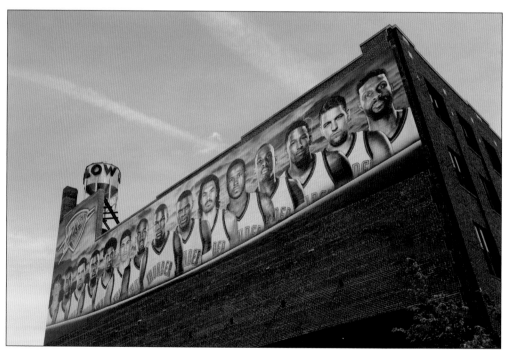

Large banners are displayed on the west wall of the Rock Island Plow Building whenever the Thunder makes an appearance in the NBA playoffs. (Courtesy of the Oklahoma Publishing Company.)

Six

THE MUSIC

Live music was part of the draw in the early days when Jim Brewer sought to transform an unknown Bricktown into a regional destination. He started with music festivals in a parking lot across from his business, O'Brien's, itself a showcase of karaoke and dueling piano players. When O'Brien's run ended, Brewer's sons Brent and Brett filled the space with the Bricktown Ballroom. The family also briefly operated a country-western live music venue, Rockabilly's.

Sheridan Avenue's other early day live music stages included the Green Door and Rocky's Music Hall & Ballroom. Years before Kings of Leon was packing stadiums nationwide, they were entertaining smaller crowds in Bricktown, charging $15 a ticket. The Bricktown Brewery hosted an array of singers and bands, including the Romantics, Men at Work, Better than Ezra, Cheap Trick, the Gin Blossoms, and Color Me Badd. The Wormy Dog Saloon added Red Dirt country music to the mix.

The diversity of music introduced by Brewer with his reggae, blues, and rock festivals was followed by the addition of the American Banjo Museum and the University of Central Oklahoma's Academy of Contemporary Music. The American Banjo Museum brought legends Roy Clark and Byron Berline to Bricktown, while the Academy of Contemporary Music at the University of Central Oklahoma, also known as ACM@UCO, hosted master classes taught by Roger Daltrey, Ben Folds, Jackson Brown, J.D. Souther, Moby, John Oates, and Nile Rodgers.

ACM@UCO gave live music a boost in Bricktown at a time when the Bricktown Brewery had stopped hosting concerts and venues like the Green Door and Bricktown Ballroom closed their doors. The college drew hundreds of students pursuing degrees in music performance, business, and production. Live annual music festivals hosted by the college grew each year, topping 20,000 people. A performance lab opened in east Bricktown to provide a small venue for students and visiting performers.

A makeover of the Bricktown Event Center transformed it into a concert venue with acts like Alt J and Ben Folds, while next door, The Criterion opened in 2016 with an increasingly full slate of performances featuring the top names in the music business. Bricktown, established in 1979, continues to thrive almost 40 years later.

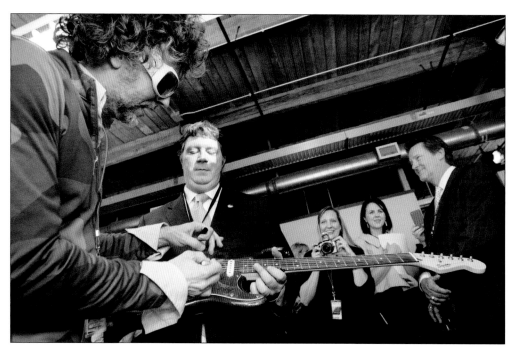

Scott Booker, longtime manager with hometown Grammy winners the Flaming Lips, worked with the University of Central Oklahoma to open a US affiliate campus for London's Academy of Contemporary Music in the Oklahoma City Hardware building along the Bricktown Canal. Booker had Lips lead singer Wayne Coyne sign a guitar at the opening of ACM@UCO. The school features music, business, production, and marketing instruction. (Both, courtesy of the Oklahoma Publishing Company.)

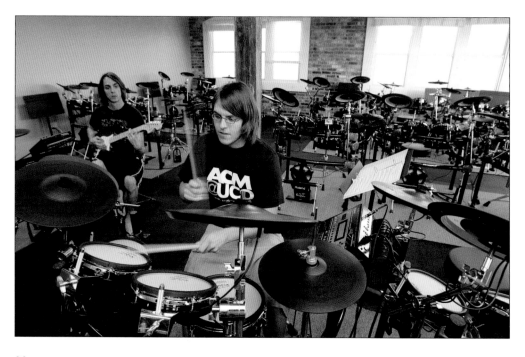

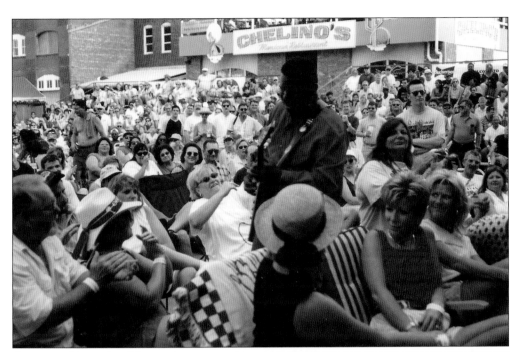

An array of legendary blues artists appeared over the past two decades at the Bricktown Blues and BBQ festival, including electric blues and soul guitarist and singer/songwriter Michael Burks. Burks had an international following and was best known as "Iron Man" for his approach to his guitar performances. (Courtesy of Brewer Entertainment.)

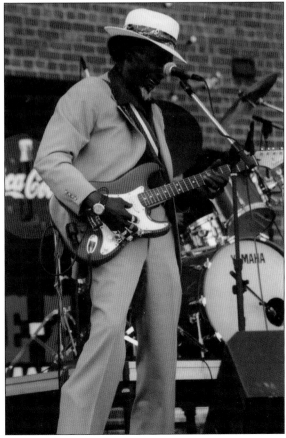

D.C. Miner, a native of Rentiesville, Oklahoma, was an Oklahoma Hall of Fame performer when he was featured at the Bricktown Blues and BBQ festival. Miner performed with Chuck Berry and Bo Diddley and was known for teaching the blues to Oklahoma schoolchildren. (Courtesy of the Oklahoma Publishing Company.)

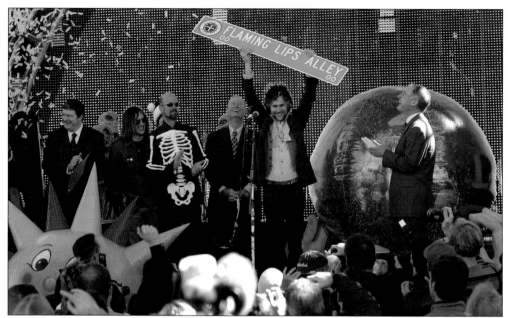

The Flaming Lips, a Grammy-winning group with an international following, got its start in Oklahoma City and have remained loyal to its hometown. The band's accomplishments and ties were honored with the naming of Flaming Lips Alley. (Courtesy of the Oklahoma Publishing Company.)

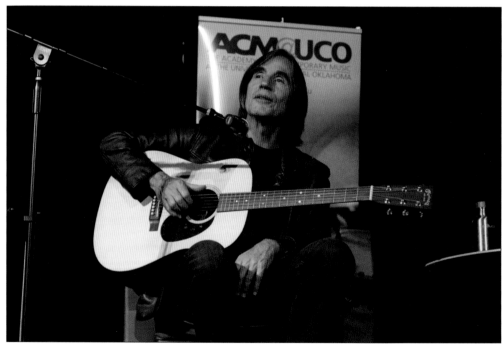

ACM@UCO regularly hosts legendary musicians who teach masters classes at the Bricktown college. Guest lecturers include Jackson Brown (shown in this photograph), Roger Daltrey, Moby, Ben Folds, and Nile Rodgers. (Courtesy of the Oklahoma Publishing Company.)

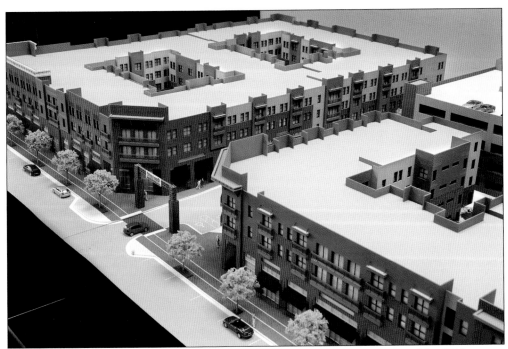

Bricktown continues to expand in 2016 with redevelopment of the former Stewart Metal Fabricators plant, which sprawled across both sides of Sheridan Avenue east of the Bricktown Ballpark. Development includes construction of Steelyard, which consists of 400 apartments, 26,000 square feet of retail space (shown at left in the aerial view below), and two hotels. Adjoining development includes at least three more hotels and The Criterion, a music venue (at right below, under construction). (Above, courtesy of Gary Courtesy Brooks; below, courtesy of the Oklahoma Publishing Company.)

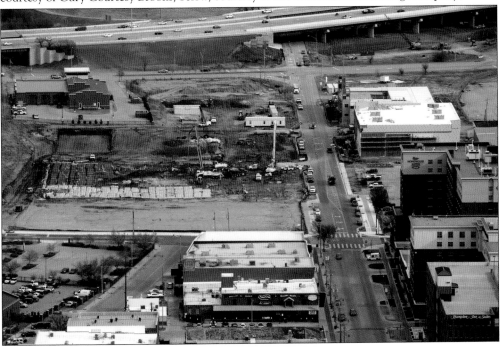

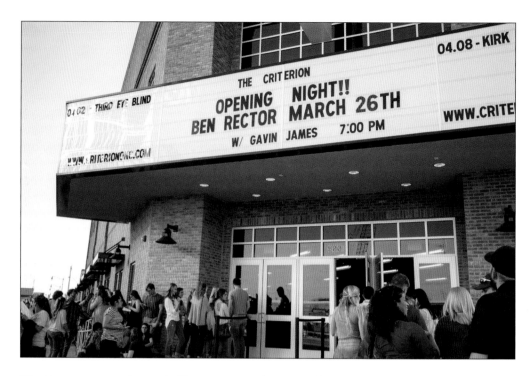

The Criterion opened to packed houses in March 2016, with an initial lineup of acts that included Third Eye Blind, shown below. The Criterion has two bars, a mezzanine level, and can accommodate up to 4,000 people. The venue is operated by Levelland Productions along with Live Nation, the world's largest live music operator. (Both, courtesy of the Oklahoma Publishing Company.)

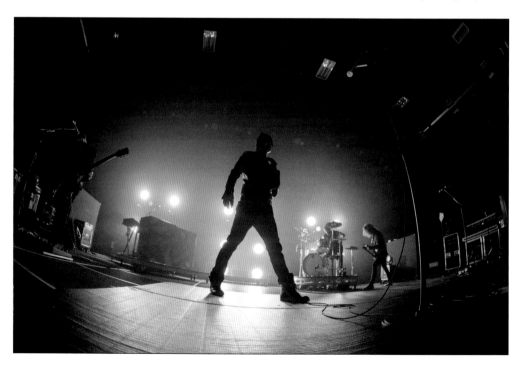

The Bricktown Bike Bar is a popular mode of transportation in Bricktown that allows visitors to enjoy some exercise and socialize while hopping from bar to bar. (Courtesy of the Oklahoma Publishing Company.)

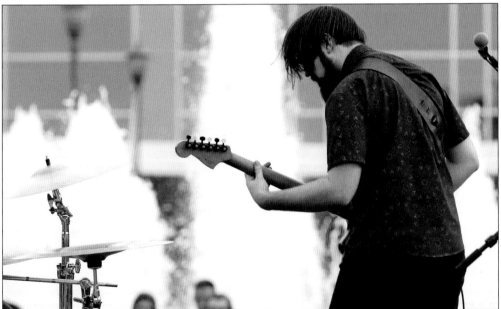

Chris Lashley plays guitar during a performance by the Happily Entitled on the Lower Bricktown Fountain Stage during the ACM@UCO Metro Music Fest. The free music festival featured veteran performers and ACM@UCO student bands at several venues in Bricktown. Live music, an early part of Jim Brewer's promotion of Bricktown, is drawing thousands to the district with a growing list of venues and acts. (Courtesy of the Oklahoma Publishing Company.)

DISCOVER THOUSANDS OF LOCAL HISTORY BOOKS FEATURING MILLIONS OF VINTAGE IMAGES

Arcadia Publishing, the leading local history publisher in the United States, is committed to making history accessible and meaningful through publishing books that celebrate and preserve the heritage of America's people and places.

Find more books like this at
www.arcadiapublishing.com

Search for your hometown history, your old stomping grounds, and even your favorite sports team.